Ellen Cantor

My Perversion is the Belief in True Love
Video/Art

Kunsthalle Wien
Scalo Zurich–Berlin–New York

with an essay by Matthew Yokobosky
and an interview with Ellen Cantor by Gerald Matt

Colophon / *Impressum*
Ellen Cantor – My Perversion is the Belief in True Love, video / art

This catalogue is published to accompany the video performance "Ellen Cantor – Within Heaven and Hell",
Kunsthalle Wien im Museumsquartier, September 10–17, 1998
Diese Publikation erscheint anläßlich der Videoperformance „Ellen Cantor – Within Heaven and Hell" in der
Kunsthalle Wien im Museumsquartier, 10.–17. September 1998

Kunsthalle Wien
Museumsplatz 1/6/1, A-1070 Wien
phone ++43/1/521 89-12 Fax -521 89-60
Ein Projekt im Rahmen der Veranstaltungsreihe OUTSIDE ART
Idee und Konzept: Gerald Matt, Kurator: Lucas Gehrmann
Die Kunsthalle Wien ist die Institution der Stadt Wien für moderne und
zeitgenössische Kunst und wird durch die Kulturabteilung MA7 unterstützt.
Dr. Gerald Matt (Direktor), Mag. Bettina Leidl (Geschäftsführung), Florian Berktold (Produktion),
Paul Lehner (Techn. Gesamtleitung), Panto Trivkovic (Transporte), Mag. Thomas Soraperra, Claudia Bauer
(Öffentlichkeitsarbeit)

Catalogue / *Katalog*

Editor / *Herausgeber*: Kunsthalle Wien
Editing / *Redaktion*: Ellen Cantor, Lucas Gehrmann
Translations / *Übersetzungen:* Elisabeth Frank-Großebner, David Gogarty
Photocredits / *Fotonachweis:* Ellen Cantor
Design / *Grafische Gestaltung:* Andrew Byrom, Simon Josebury at Secondary Modern, London
Special thanks to Jason Rand for his initial design work on this project
Printing / *Druck:* Holzhausen, Wien/Austria

Outside Art, Within Heaven and Hell, Ellen Cantor, Synthesiser

Within Heaven and Hell is the title of one of Ellen Cantor's works for video dating from 1996 and, simultaneously, the programmatic title of the artist's own contribution to the Kunsthalle Wien's series of projects known as *Outside Art*. The latter has been running parallel to the building and transfer of the Kunsthalle since 1998 and has featured two curated projects a year within the entrance area of the exhibition halls at Karlsplatz and the Museum Quarter (the future location of Kunsthalle Wien). *Outside Art* will take place outside conventional art spaces – thus stressing its event character and interactive features – and is geared towards the public and a continually changing environment.

Ellen Cantor will be projecting her videographic work in the Museum Quarter, between the architectural remains of the former Imperial Court Stables and the building site for the future museums and the Kunsthalle Wien, on two September evenings. This event will be advertised by posters created by the artist – amongst other places in the show cases of the Kunsthalle Wien at Karlsplatz. If the setting often appears to be a medley of old and new, temporary and permanent elements, heaps of rubble and excavation works, it is nevertheless the result of methodical, logical and structural thinking – in other words, a frame of mind that stands for a well-ordered world, with clear categories and lines of demarcation, and that is above all directed outwards and determines the targets that will shape public life.

Given the dichotomies of Western reason and morality, that is, when the world is clearly classified into categories of the beautiful, the true, the good and the righteous – and their opposites – Ellen Cantor's work could be difficult to understand. The New York artist, who now lives in London, enters this world of carefully cultivated regulations, requirements and prohibitions, limitations and indicators, with pictorial narratives, videos and photomontages, that severely disturb our pre-conditioned distinctions between heaven and hell, hard and soft, sex and love, art and trash. Thus, pornographic episodes undermine Cinderella's comely modesty and a comic strip reminiscent of Robert Crumb abounds with sexual fantasies of two women making love to one another.

"How do women image their desire?" asks Ellen Cantor and – because she found no public statements to this effect – formulates her own, both on the smaller format of drawing paper and in larger formats on the walls of galleries and exhibition halls or in her photographic and film collages. As in a diary, the same figures crop up again and again and reflect the artist's real, as well as imaginary, experience. Ellen Cantor uses both continuous narrative structures and twists, contrasts and contradictions to counteract the narrative's linear character and undermine comforting certainties.

She uses stereotype images and clichés of beauty and violence transmitted by the media just as much as very personal and, indeed, publicly proscribed images. She assembles them partly from existing film material and creates added contrast with the help of sampled music and under-titles. "For the most part, romantic movies do not portray penetration, and porn movies lack emotions and poetry." Ellen Cantor succeeds in bringing both elements together, but sometimes – even one hundred years after Freud's *Interpretation of Dreams* – her samplings of inner and outer images, rich in contrast as they often are, are indeed "difficult" to digest: one of her exhibitions was not even unveiled in Zurich in 1995 due to the allegedly pornographic content of her work.

"Female representation of sexuality is still largely unexplored territory, which is why a woman simply describing her own experiences and desires is somehow considered radical." Ellen Cantor's works identify a pivotal point in a society where the individual has gained a great deal of personal freedom on the one hand, and, on the other hand, which is marked by the disintegration of traditional values (which brings with it the danger of a backlash and the re-establishment of hidebound structures): she avoids taking up ideological or polemical positions either one way or the other, but tries instead to provide us with an opportunity for unequivocal self-reflection with the aid of a myriad of mirrors and works towards the synthetical broadening of understanding for the self and the "alien", the other (alter ego).

We would like to thank the artist in particular, who has not only put her videographic work at our and the public's disposal, but who also devoted a great deal of time and energy to the realisation of the catalogue. We would also like to offer Mr. Walter Keller our cordial thanks, whose publishing interest in the work of Ellen Cantors has made such a comprehensive publication possible. Naturally, we are especially pleased that Matthew Yokobosky (who is a specialist in artistic videos and an authority on the work of Ellen Cantor) was prepared to make such a significant contribution to the catalogue. Furthermore, we would like to thank all who have contributed to the realisation of this project with their advice and support – not least the Kunsthalle Wien team.

Gerald Matt, Director of the Kunsthalle Wien
Lucas Gehrmann, curator, Kunsthalle Wien

Translated from German by David P. Gogarty

Outside Art, Within Heaven and Hell, Ellen Cantor, Synthesizer

Within Heaven and Hell lautet der Titel einer Videoarbeit Ellen Cantors aus dem Jahr 1996, und *Within Heaven and Hell* ist zugleich der programmatische Titel des Beitrags der Künstlerin für die Projektreihe *Outside Art* der Kunsthalle Wien. Seit 1998 begleitet *Outside Art* den Neubau und Umzug der Kunsthalle mit jeweils zwei kuratierten Projekten pro Jahr in den Einzugsbereichen der Ausstellungshallen am Karlsplatz und im Museumsquartier, dem zukünftigen Standort der Kunsthalle Wien. *Outside Art* findet als Kunst außerhalb der Kunst-Räume statt, hat somit schwerpunktmäßig Event-Charakter oder interaktive Eigenschaften, rechnet mit Öffentlichkeit und sich wandelnder Umgebung.

An zwei September-Abenden projiziert Ellen Cantor zwischen den architektonischen Resten der ehemaligen k.k. Hofstallungen sowie den Baugruben neu zu errichtender Museen und der Kunsthalle Wien ihr videographisches Werk ins Museumsquartier – eine Veranstaltung, die durch Posters, die die Künstlerin gestaltet hat, u. a. auch in den SchauFenstern der Kunsthalle Wien am Karlsplatz angekündigt wird.

Erscheint dieses Ambiente insgesamt als ein Durcheinander von Alt und Neu, Temporärem und Dauerhaftem, Bauschutthügeln und Aushublöchern, so steht dahinter doch ein planerisches, logisches, konstruktives Denken. Ein Denken, das zugleich eine Welt der Ordnung, der klaren Abgrenzungen und Kategorisierungen versinnbildlicht, ein Denken, das vor allem nach außen wirkt, Maßstäbe setzt, das öffentliche Leben strukturiert.

Das Verständnis für Ellen Cantors Arbeit mag nun gerade dort auf Schwierigkeiten stoßen, wo die Welt klar eingeteilt ist in die Kategorien des Schönen, Wahren, Guten, Richtigen ... und deren Gegensätze. In diese Welt der sorgsam gepflegten Regeln, Ge- und Verbote, Grenzen und Wegweiser tritt Ellen Cantor ein mit Bildgeschichten, Videos und Fotomontagen, die unser konditioniertes Unterscheidungsvermögen zwischen Himmel und Hölle, hard und soft, Sex und Liebe, Kunst und Schund heftig irritieren. Da wird zum Beispiel die liebenswerte Bescheidenheit eines Aschenputtel mit pornografischen Szenen unterwandert; oder ein Comicstreifen im Zeichenstil eines Robert Crumb erzählt – gespickt mit Bildern sexueller Phantasien – vom Liebesakt zweier Frauen.

„Wie stellen Frauen ihre Wünsche dar?", fragt Ellen Cantor, und da sie in unserer Gesellschaft dazu keine öffentlichen Mitteilungen findet, formuliert sie sie selbst, zunächst auf kleinen Zeichenblättern wie im Tagebuch, dann großformatig auf den Wänden von Galerien und Ausstellungshäusern, oder in Form von Foto- und Filmcollagen.
Sie arbeitet dabei mit Erzählstrukturen, läßt immer wieder dieselben Figuren auftreten, die tagebuchartig reale und fiktive Erlebnisse der Künstlerin reflektieren, und sie arbeitet gleichzeitig mit Brüchen, Gegensätzen, Widersprüchen, die die Linearität solcher Erzählung unterwandern, gewohnte Grenzen durchbrechen, Gewißheiten destabilisieren. Sie verwendet stereotype Bilder und medial weitverbreitete Klischees von Schönheit und Gewalt ebenso wie ganz private und öffentlich tabuisierte Bilder, schneidet sie aus z.T. bestehendem Filmmaterial zusammen und schafft mittels gesampelter Musik und unterlegten Texten zusätzliche Kontraste.

„So gut wie nie wird in romantischen Liebesfilmen Penetration gezeigt, und in Pornofilmen fehlen Gefühle und Poesie."
Ellen Cantor bringt beides zusammen, doch auch hundert Jahre nach Freuds *Traumdeutung* sind ihre Kombinationen aus inneren und äußeren Bildern „manchmal schwierig" zu verdauen: Noch 1995 wurde eine Ausstellung ihrer Werke in Zürich wegen des Vorwurfs der Pornographie erst gar nicht eröffnet.

„Die Darstellung weiblicher Sexualität ist nach wie vor ein leeres Feld. Aus diesem Grund wird eine Frau, die einfach ihre eigenen Erfahrungen und Wünsche beschreibt, in irgendeiner Form für radikal gehalten."
In einer Gesellschaft, in der sich das Individuum einerseits viel Freiraum errungen hat, in der aber andererseits die Destabilisierung traditioneller Werte die Gefahr der Reaktion, der Reinstallation alter Strukturen in sich birgt, markiert das Werk von Ellen Cantor einen Angelpunkt: Indem sie nicht ideologisch-polemisch Stellung nach hie oder da bezieht, sondern mittels vieler Spiegel unserer selbst die Möglichkeit einer vorbehaltlosen Selbst-Sicht schafft, arbeitet sie im Sinne einer Synthese an der Öffnung des Verständnisses für sich selbst und das „Fremde", das andere (Ich).

Unser Dank richtet sich zuallererst an die Künstlerin, die uns und dem Publikum der Kunsthalle Wien nicht nur ihr videographisches Werk zur Verfügung stellt, sondern zugleich auch – zwischen London, New York und Wien pendelnd – intensiv an der Realisierung des Kataloges gearbeitet hat. In diesem Zusammenhang möchten wir Herrn Walter Keller herzlich danken, dessen verlegerisches Interesse am Werk Ellen Cantors die Produktion einer umfangreichen Publikation erst ermöglicht hat. Auch freuen wir uns besonders, daß Matthew Yokobosky als Spezialist für künstlerisches Video und Kenner von Ellen Cantors Arbeit bereit war, den Hauptbeitrag des Katalogs zu verfassen.
Weiters gilt unser Dank allen, die sonst noch mit Rat und Tat an der Realisierung dieses Projekts beteiligt waren, last not least dem Team der Kunsthalle Wien.

Dr. Gerald Matt, Direktor der Kunsthalle Wien
Lucas Gehrmann, Kurator, Kunsthalle Wien

Filling the Ellipsis … The Public Videotapes of the Private Ellen Cantor

By Matthew Yokobosky

"Warning: This cinema is showing pornographic films depicting close-ups of sexual intercourse, oral sex, and male and female masturbation and is not for the easily shocked".[1]

This warning was displayed in the front of a London pornographic film theater in the late 1970s, as a means to dissuade customers from intentionally disrupting the screening; since, the majority of their patrons were not there in protest, but by choice in the theater to have their sexual desires stimulated. Beginning in the mid-1960s, when pornographic films were brought from their secreted position in brothels and mens' clubs and into public viewing establishments, they frequently have been the target of protests, most conspicuously by Feminist critics who argued that pornographic films encouraged men to rape and sadistically torture women. In Gertrud Koch's essay The Body's Shadow Realm, she argues that "one can object to arguments that posit a direct connection between viewing pornographic films and engaging in [violent] sexual acts … [since] it has never been proven that filmed events have a direct effect on human behavior".[2] While Koch's blanket statement asserts an unpopular stance, the larger remaining dilemma is that pornographic images maintain an aura of secrecy and forbidden, the sensational and the never-before seen and consequently provoke extreme reactions when shown in public.

It has been speculated that pornographic imagery only becomes acceptable when it has acquired the characteristic of being antique—50 years or older—or if it is a creation by an artist. Antique representations, those that were produced or acquired in an era in which overt sexuality was admonished, before 1950, and were usually relegated to private collections, not public displays. As such even artists' protrayals of explicit sexuality were hidden and remained so until his/her death. As an example, Man Ray's film Two Women (c. 1920s) never appeared in his filmography until 1997, when the film was discovered among his personal effects.[3] Art, in the past (antique) or the present, has neither provided a safe haven for graphic nude and sexual displays, as recent government censorship has proven: Ellen Cantor being a case in point. In 1995, her installation within a publicly funded art institution, in the cosmopolitan city of Zurich, was deemed offensive and was subsequently closed. The taboo of publicly exhibiting sex and nudity remains, which acknowledges that these works remain safe only as private commodities. The rarified environment of the artworld does not provide immunity from oppression. Thus, while Cantor's videotapes are produced in a presumeably tolerant and liberated modern culture, they have continued to shock due to their overt depictions, or as Roberta Smith has stated in a review of Cantor's works, "they push too hard at the limits of social acceptability."

Filling the Ellipsis … Die öffentlichen Videobänder der privaten Ellen Cantor

Matthew Yokobosky

„Warnung: Dieses Kino zeigt pornographische Filme mit Nahaufnahmen von Geschlechtsverkehr, Oralverkehr und Masturbationsszenen mit Personen beiderlei Geschlechts, welche für Zartbesaitete nicht geeignet sind."[1]

Diese Warnung wurde Ende der siebziger Jahre am Eingang zu einem Londoner Pornokino angebracht, um zu verhindern, daß Besucher vorsätzlich die Vorstellung unterbrachen, denn die Stammgäste waren vielmehr aus freien Stücken dort, nicht um zu protestieren, sondern um sich sexuell erregen zu lassen. Ab Mitte der sechziger Jahre, als die Pornofilme aus ihren Verstecken in Bordellen und Herrenclubs in die öffentlichen Filmtheater kamen, waren sie immer wieder das Ziel von Protesten, besonders von seiten der feministischen Kritik, die dahingehend argumentierte, daß Pornofilme die Männer dazu ermutigten, Frauen zu vergewaltigen und sadistisch zu quälen. In Gertrud Kochs Essay Das Schattenreich des Körpers meint die Autorin in etwa, daß Argumente, die eine direkte Verbindung zwischen dem Betrachten von Pornofilmen und sexueller Gewalt postulieren, widerlegbar sind, … [da] niemals bewiesen wurde, daß gefilmte Ereignisse eine direkte Auswirkung auf das menschliche Verhalten haben.[2] Kochs Pauschalaussage gibt eine unpopuläre Haltung wieder, das Dilemma, das bleibt, ist aber größer als das: Pornographische Bilder verbreiten eine Aura des Geheimnisvollen und Verbotenen, des Sensationellen und nie Dagewesenen. Werden sie in der Öffentlichkeit gezeigt, kommt es in der Folge zu Extremreaktionen.

Es wurde immer wieder spekuliert, daß Pornographie im Bild erst dann akzeptabel wird, wenn sie einen gewissen Altertumswert hat – d.h. fünfzig Jahre oder älter ist – oder von einem Künstler geschaffen wurde. Alte Darstellungen, das waren jene, die vor 1950 produziert oder erworben wurden, in einer Zeit, als offene Sexualität Verweise nach sich zog, und die normalerweise in Privatsammlungen verborgen und nicht öffentlich zur Schau gestellt wurden. In diesem Sinn versteckte man auch die von Künstlern geschaffenen Porträts expliziter Sexualität bis zum Tod der Urheber. So schien Man Rays Film Two Women (um 1920) nie in dessen Filmographie auf, bis der Film 1997 unter seinen persönlichen Besitztümern gefunden wurde.[3] Die Kunst war weder in der Vergangenheit noch in der Gegenwart eine Schutzzone für die explizite Zurschaustellung von Nacktheit oder Sexualität – jüngste Fälle von staatlicher Zensur, wie bei Ellen Cantor, haben das einmal mehr gezeigt. Im Jahr 1996 empfand man ihre Installation in einer öffentlich subventionierten Kunstinstitution in der Weltstadt Zürich als anstößig, was zur Schließung führte. Die öffentliche Darstellung von Sex und Nacktheit bleibt weiterhin ein Tabu, wodurch bestätigt ist,

While the display of videotape continues to gain visibility as an artform, the "art videotape" continues to struggle against censorship, which reflects the struggles that mainstream film directors have encountered in Hollywood. Prior to 1969, sex had functioned symbolically in commercial cinema, and graphically in the underground stag film. For example, in a commercial feature when a couple displayed sexual passion, the camera frequently panned to an open window or cut to a display of fireworks. In stag films by contrast, close-ups of sexual penetration were usually followed by shots of ejaculation. The discrete verses the explicit. By 1969, after the United States Supreme Court ruled that adults had the right to see explicit materials and the Motion Picture Association of America repealed the Production Code of America (known colloquially as the "Hayes Code"), Hollywood cinema produced more sexually challenging work (*Midnight Cowboy*, John Schlesinger, 1969) and equally significant, the adult film industry became legal. Although commercial cinema did not introduce graphic penetration and ejaculation shots into their vocabulary, the doors to a more sexually embracing cinema were ajar. At this moment, Ellen Cantor, along with artists such as Peggy Ahwesh, Lydia Lunch, Richard Kern, and Franco Marinai, are making important advances in the integration of graphic sex within contemporary film and video art.

In works such as *Ode to Life* (1997), Cantor subverts the expectations of the viewer by integrating hardcore pornographic imagery alongside neutral film imagery–viewers do not expect to see sexually explicit material in either art or commercial film imagery. *Ode to Life* begins with a static image of a woman's head, as if unconscious or laying down. While this image lingers on the screen, Cantor recounts the story of an automobile accident she survived: while driving through Germany and listening to music, a strong feeling of happiness overcame her and she speculated that it would be a perfect moment to die. At that very instant a block of ice fell off a truck and smashed into her windshield, causing the vehicle to almost career off the road. Following this prologue, two minutes of ejaculation shots followed. Cantor's voiceover then states that "in every drop of cum there is life and there is death". In juxtaposing the two events, she concludes that life (the scattershot possibility that one sperm will yield life) and death (which may end just as unexpectedly and abruptly as life begins) are such random occurences that have no predictable beginning or end. Cantor then ends the three-minute tape with a microscopic shot of swimming sperm, which re-focuses the discussion to the scientific. As *Ode to Life* was produced in the 1990s, during the AIDS crisis and sexual fear, she concludes that the creation of life and the advent of death are randon, like the unexpected, symbolic juxtapositions of the videotape itself.

daß diese Werke nur als private Güter sicher sind. Die Luft in der Kunstszene ist dünn und bietet keine Immunität vor Unterdrückung. Während Cantors Videos in einer angeblich toleranten und freien modernen Kultur produziert werden, sind sie in ihrer offenherzigen Darstellung nach wie vor schockierend, oder – wie Roberta Smith in einer Rezension von Cantors Arbeiten meinte – „sie versuchen zu heftig, die Grenzen der gesellschaftlichen Akzeptanz zu verschieben".

Während die Vorführung von Videobändern als Kunstform ein immer stärkeres Profil gewinnt, kämpft das „künstlerische Video" nach wie vor mit der Zensur, was die Kämpfe, die Mainstream-Filmregisseure früher in Hollywood auszufechten hatten, widerspiegelt. Vor 1969 gab es Sex im kommerziellen Kino nur symbolisch und im Underground-Film für den Herrenabend in sehr direkter Form. Hatte in einem kommerziellen Film ein Paar sexuelle Leidenschaft zu mimen, dann kam häufig ein Schwenk auf ein offenes Fenster oder ein Schnitt zur Einstellung, die ein Feuerwerk zeigt. In den Herrenabendfilmen hingegen folgte auf die Penetration üblicherweise die Einstellung mit der Ejakulation – hier diskret, dort explizit. Nachdem 1969 der Oberste Gerichtshof der Vereinigten Staaten entschieden hatte, daß Erwachsene dazu berechtigt waren, explizites Material zu sehen, und der US-Filmverband den Production Code of America (allgemein als „Hayes-Code" bekannt) außer Kraft gesetzt hatte, produzierte Hollywood sexuell offenere Filme (*Midnight Cowboy* von John Schlesinger, 1969) und – eine ebenso signifikante Folge – die Pornofilmindustrie wurde legalisiert. Wenn der kommerzielle Film auch nicht Einstellungen mit expliziter Penetration und Ejakulation in seine Bildsprache aufnahm, so standen doch einem sexuell aufgeschlosseneren Filmen Tür und Tor offen. Derzeit sind Ellen Cantor und andere KünstlerInnen wie Peggy Ashwesh, Lydia Lunch, Richard Kern und Franco Marinai bahnbrechend, was die Integration unverschleierter Sexualität in die zeitgenössische Film- und Videokunst angeht.

In Arbeiten wie *Ode to Life* (1997) konterkariert Cantor die Erwartungen der Zuschauer, indem sie Bilder aus Hardcore-Pornos mit neutralen Bildern vermischt – die Zuschauer erwarten weder in der Bildsprache der Kunst noch des Kommerzkinos Material, das explizit sexuelle Akte darstellt. *Ode to Life* beginnt mit der statischen Aufnahme des Kopfes einer Frau, als läge sie ausgestreckt da oder wäre bewußtlos. Das Bild verharrt auf der Leinwand, während Cantor die Geschichte eines Autounfalls erzählt, den sie überlebte: Auf der Fahrt durch Deutschland hörte sie im Auto Musik und wurde von einer Welle von Glücksgefühl erfaßt. Sie meinte, es wäre ein perfekter Moment, um zu sterben. In diesem Augenblick löste sich ein Eisblock von einem LKW und zertrümmerte die Windschutzscheibe ihres Wagens, der von der Straße abkam. Diesem Prolog folgen zwei Minuten *cum shots*. Im Voice-over meint Cantor, daß „jeder Tropfen Sperma Leben und Sterben in sich trägt." Indem sie die beiden Geschehnisse miteinander in Verbindung bringt, kommt sie zu dem Schluß, daß das Leben (die minimale Möglichkeit, daß aus einer Samenzelle Leben entsteht) und der Tod (der ebenso plötzlich und abrupt eintreten kann, wie Leben beginnt) zufällige Ereignisse sind, die keinen vorhersehbaren Anfang und kein voraussagbares Ende haben. Cantor beendet das dreiminütige Video schließlich mit einer Mikroskopaufnahme von schwimmendem Sperma, mit dem die Diskussion in den wissenschaftlichen Bereich gebracht wird.

Cantor's choice to use a placid, neutral face for her opening shot, positions the viewer to be surprised, since one would expect to see a joyous face during sexual activity–as it has been defined in the cinema–before ejaculation. The human face, though, during sexual climax does not display joy and epiphany, as portrayed in most erotic films; the human face during sexual climax more usually approximates the expression of pain. The wrenched face is therefore how we experience and see sex in our lives, and the joy while not visible is experienced internally; therefore, the joyous facial expressions in film are visual repesentations of the internal feeling. If film represented sex as unpleasant by using faces with painful expressions, the erotic film would not appear to be joyful–sex would appear as a transgressive, violent act. This contradiction between erotic pain/pleasure is perhaps the conjunction at which many of the underlying discrepancies arise regarding the representation of sexuality in art and film, and why films are protested for eliciting "unnatural" acts. Our real experiences of sex do not match those represented in art or film, and therefore, whether the shot it joyous or "neutral" our internal vision does not match the on-screen representation, and puts our minds into a state of confusion.

In related works, Cantor juxtaposes shots of both sex and violence as a means to integrate the obscenity of realism, filling the ellipsis created in commercial film. Frequently violence is shown off-screen to allow the mind to speculate on the gruesomeness of the action, and sexual encounters likewise, as discussed earlier, been represented by open windows and fireworks. As an example, in *Within Heaven and Hell* (1996), Cantor intersplices scenes from two films, with each representing one aspect of a sexual relationship she had: *The Sound of Music* (Robert Wise, 1965) representing an idealistic vision of a romantic love, and *The Texas Chainsaw Massacre* (Tobe Hooper, 1974) representing the violence that lurks beneath the fantasy of the "real". Beginning with Maria's (Julie Andrews) twirl atop a green Austrian mountain and Leatherface's (Gunnar Hansen) twirl while weilding a smoking chainsaw, Cantor sets-up a parallel between the idealic and the macabre. Both Maria's "family" and Leatherface's "family" become extreme iconic family types as constructed in film: the idealized and the disfunctional. But by opening the videotape with a scene of Maria, the scenes from *Texas Chainsaw* appear to be an insertion of macabre within Maria's idyllic life. The fake pleasantries of *The Sound of Music* are merely a disguise for the grotesque realities of hate and anger that are over-dramatized in *Texas Chainsaw*. *Within Heaven and Hell* then serves as a metaphor for a relationship, in which Cantor experienced a wide range of emotions.

Stylistically, *Ode to Life* and *Within Heaven and Hell*, along with the works *Madame Bovary's Revenge* (1995) and *Remember Me* (1998), utilize videotape redubbing as a means for artistic creation. Described as appropriation during the late 1980s and later as

Ode to Life entstand in den neunziger Jahren, während AIDS-Krise und Angst vor Sexualität herrschten, und so schließt sie, daß die Entstehung neuen Lebens und der Moment des Todes ebenso zufällig sind wie die unerwarteten, symbolischen Gegenüberstellungen von Bildern auf dem Video.

Cantors Entscheidung, ein gelassenes, neutrales Gesicht als erste Einstellung zu wählen, sorgt für Überraschung beim Zuschauer, da man bei sexueller Aktivität – wie sie durch den Film definiert ist – vor der Ejakulation ein Gesicht erwarten würde, das Lust und Freude ausstrahlt. Das Gesicht des Menschen tut beim sexuellen Höhepunkt allerdings nichts dergleichen, auch wenn es in erotischen Filmen meist so dargestellt wird, es hat üblicherweise eher einen schmerzerfüllten Ausdruck. Das verzerrte Gesicht zeigt also, wie wir Sex im Leben erfahren und sehen; Freude und Lust empfinden wir innerlich, sie dringen nicht nach außen. Daher sind glückliche Gesichter im Film die visuelle Darstellung des inneren Gefühls. Würde Sex im Film durch schmerzverzerrte Gesichter als etwas Unangenehmes dargestellt, hätte der erotische Film nichts Lustvolles an sich – Sex würde als Transgression, als Gewaltakt gezeigt. Dieser Widerspruch zwischen erotischem Schmerz und Lust ist vielleicht die Schnittstelle, an der viele der fundamentalen Diskrepanzen bei der Darstellung von Sexualität in Kunst und Film entstehen, und der Grund, warum man gegen Filme wegen der Anstiftung zu „unnatürlichen" Handlungen protestiert. Unsere wahren Erfahrungen mit Sex stimmen nicht mit jenen überein, die uns Kunst und Film zeigen, und daher entspricht unsere innere Sichtweise nicht der Darstellung auf der Leinwand, egal, ob das Gesicht einen glücklichen oder „neutralen" Ausdruck hat – wir sind jedenfalls verwirrt.
In verwandten Arbeiten stellt Cantor Bilder, die Sex und Gewalt zeigen, als Mittel nebeneinander, um das Obszöne am Realismus darzustellen, um die Ellipse im Kommerzfilm zu ersetzen, die Lücke zu füllen. Oft wird im Film Gewalt ins Off verlegt, damit man sich seine eigenen Vorstellungen über die Grauenhaftigkeit der Handlung machen kann, und anstelle sexueller Begegnungen gibt es den bereits erwähnten Schwenk auf offene Fenster oder Feuerwerke. So etwa verwebt Cantor in *Within Heaven and Hell* (1996) Szenen aus zwei Filmen miteinander, von denen jeder für einen Aspekt einer sexuellen Beziehung steht, die sie hatte: *The Sound of Music* (Robert Wise, 1965) für die idealistische Darstellung einer romantischen Liebe und *The Texas Chain Saw Massacre* (Tobe Hooper, 1974) für die Gewalt, die unter der Vorstellung vom „Realen" lauert. Ausgehend von Maria (Julie Andrews), die auf einer grünen Alm in den österreichischen Alpen umherwirbelt, und Leatherface (Gunnar Hansen), der mit der erhobenen Kettensäge umherwirbelt, schafft Cantor eine Parallele zwischen dem Idealisierten und dem Makabren. Marias „Familie" und Leatherfaces „Familie" werden zu extremen, ikonenhaften Familientypen, wie sie der Film konstruiert: die idealisierte und die funktionsgestörte Familie. Das Video beginnt mit einer Szene mit Maria, so daß die Sequenzen aus dem Horrorfilm makabre Zwischenspiele in Marias idyllischem Leben zu sein scheinen. Die zuckersüßen Plaisanterien von *The Sound of Music* sind lediglich eine Fassade für die groteske Wirklichkeit von Liebe und Haß, die im *Texas Chainsaw Massacre* überdramatisiert werden. *Within Heaven and Hell* dient somit als Metapher für eine Beziehung, in der Cantor eine Vielzahl von Emotionen durchlebte.

homage, Cantor's video aesthetic more accurately relates to the historical reproduction of the stag film. Since stag films were produced illegally, they could not be duplicated and processed in commercial laboratories. Therefore, the films had to be duplicated through re-photography (projecting the film and filming the image off the wall) and subsequently had to be developed in homemade chemical solutions. The unavoidable results–often because the duplicators themselves were often amateurs–were that the films were often technically out-of-focus, off-register, and the scratched film surfaces were magnified, while the film material itself was often water marked and under/over developed. This detourned film aesthetic was as such an unconscious aesthetic development that consequently was seen as a created aesthetic, as opposed to a condition of its very existence.

In Cantor's work, she consciously uses the illegal replication of videotape as a production technique emphasizing the grain of the video image, and therefore the surface noise or interference as a means to draw awareness to the image, and invite examination. Like the scratching and detournement of the film image, the decomposition and instability of the video image is seen as a flaw, as opposed to a desired effect and therefore the viewer is aware of the video image as a reproduction, as opposed the flawless, realistic image in film or video that is mean't to mirror life. The effect, when applied to erotic imagery

though, also has an opposite effect: heightened realism. Because of the advanced knowledge of moving image quality in film and video by the public, the raw, unprofessional footage of erotica has garnered the moniker of "amateur" porn. "Amateur" being used as a term to describe pornographic videotapes produced by untrained videographers featuring "real" performers, not the pristine, glossy images of the pornographic industry which feature manicured sexual athletes. As such, Cantor's use of video re-dubbing evokes a heightened realism.

In her work Club Vanessa (The London Tape; 1997), Cantor utilizes the technique of home videography to record her own sexual adventures. At the top of the work, she candidly states, "we have loves everywhere … let's make movies of it", and proceeds to experience open sexual engagements with a series of partners. By placing herself in the works as opposed to representing her life through commercial film imagery and her own voiceover, Cantor has taken the level of personal disclosure to its visual and aural extreme. In Madame Bovery's Revenge, when Cantor inserted pornographic close-ups within the sexual scenes from Les Amants (Louis Malle, 1959), the ellipses of Malle's film were filled and therefore Jeanne Moreau's character's passion was no longer imaginary. Similarly, Cantor's sexual involvements are not imaginary. By filling the film ellipses/"absence" she has also erased the imagined erotics of the story, and consequently the viewer must

Ode to Life und Within Heaven and Hell – ebenso wie die Arbeiten Madame Bovarys's Revenge (1995) und Remember Me (1998) – setzen das Stilmittel der Videoneuvertonung als schöpferische Ausdrucksmöglichkeit ein. In den achtziger Jahren als Aneignung beschrieben, später als Hommage, nimmt Cantors Videoästhetik eigentlich eher auf die historische Reproduktionstechnik für Herrenfilme Bezug. Da diese illegal produziert wurden, konnten sie auch nicht in kommerziellen Labors vervielfältigt und ausgearbeitet werden. Sie mußten zur Vervielfältigung bei der Vorführung abgefilmt und dann in selbstgemischten chemischen Lösungen entwickelt werden. Oft waren die Leute, die die Filme reproduzierten, selbst Amateurfilmer, so daß die Ergebnisse unvermeidlicherweise unscharfe Bilder, verschobene Rapports und zerkratzte Oberflächen waren, die noch vergrößert wurden; das Filmmaterial wies Wasserspuren auf und war über- oder unterbelichtet. Diese verschobene filmische Ästhetik war als solche eine unbewußte Entwicklung, die in der Folge zur gewollten schöpferischen Ästhetik wurde, welche eigentlich einer Bedingung ihrer Existenz zuwiderlief.

Cantor setzt in ihren Arbeiten bewußt die illegale Reproduktion von Videos als Produktionstechnik ein, sie betont die Körnigkeit des Videobildes und damit Oberflächenrauschen oder Interferenz, um den Zuschauern das Bild bewußt zu machen und zur genaueren Untersuchung aufzufordern. Wie das Zerkratzten und Verschieben des Videobilds gelten auch dessen Auflösung und Unschärfe als Mangel, der nicht den gewünschten Effekt erzielt. Damit wird den Zuschauern bewußt, daß es sich um eine Reproduktion handelt, nicht um das makellose realistische Film- oder Videobild, das das Leben widerspiegeln soll. Der Effekt läuft aber, wenn man ihn auf erotische Bilder anwendet, auch auf das Gegenteil hinaus: auf verstärkten Realismus. Das Publikum weiß heute mehr über die Qualität der bewegten Bilder in Film und Video, so daß unbearbeitete und unprofessionelle erotische Filmsequenzen mit der Bezeichnung „Amateurpornos" assoziiert werden. „Amateurfilm" bedeutet in diesem Zusammenhang Pornovideos, gemacht von unausgebildeten Videofilmern mit „echten" Darstellern, nicht die makellosen, glänzenden Bilder der Pornoindustrie mit ihren manikürten Sexathleten. Damit evozieren Cantors nachvertonte Videos verstärkten Realismus.

In ihrer Arbeit Club Vanessa (The London Tape, 1997) benützt Cantor die Technik des Heimvideos, um ihre eigenen sexuellen Abenteuer aufzuzeichnen. Am Anfang der Arbeit meint sie offenherzig: „Wir haben überall unsere Liebschaften … machen wir also Filme darüber", und sie zeigt danach unverhüllte sexuelle Erfahrungen mit einer Reihe von Partnern. Indem sie sich selbst in den Arbeiten darstellt, anstatt ihr Leben durch Bilder aus Kommerzfilmen mit der eigenen Stimme aus dem Off zu zeigen, hat Cantor die Offenlegung ihrer persönlichen Verhältnisse ins visuelle und auditive Extrem gesteigert.
In Madame Bovary's Revenge baute Cantor in sexuell geladene Szenen aus dem Film Les Amants (Louis Malle, 1959) Großaufnahmen aus Pornos ein, mit denen sie die Ellipsen in Malles Film ersetzte, wodurch die Leidenschaft der von Jeanne Moreau gespielten Frau nicht mehr allein in der Vorstellung existierte.

engage in the image as factual as opposed to his or her own imaginations. Cantor also inserts a discussion about film editing, which acknowledges the inclusion/exclusion of material in filmmaking and how they define the character of a film as a fictional narrative verses erotica verses pornography. *Club Vanessa* acknowledges that the sequence of film/videotape shots are constructed and that the film/videotape's texture are both used to navigate the viewers imagination between realism and fantasy, and that the filmmaker has the aesthetic perogative to define the viewers' experience.

By negotiating between the private experience of creating videotapes and presenting those works in a public forum, Ellen Cantor is creating an open sexual dialogue with the viewer. Using recognizable, publicly accepted images from cinema and presenting the works in public venues (art and video galleries), she begins this exchange by subverting the usual art/viewer relationship. Through this technique, Cantor confronts viewers with complex images and stories that reflect on relationships and specifically sexuality. By using her private experiences as source material as well as aesthetic techniques that suggest realism, she fills in the ellipses created by commercial cinematic language and as a result creates a cinematic *fait accompli*, as opposed to an induced fantasy. Cantor's videotapes are thus an exploration of the boundaries between the imagined and the real; between the erotic and the pornographic; between the symbolic and the actual; between the public and the private—points which are central to the debate concerning the exhibition of nudity and sexuality within the art world and the world at large.

1 John Ellis, *On Photography*, in: *Screen*, vol. 21, no. 1 (Spring 1980), p. 103.

2 Gertrud Koch, *The Body's Shadow Realm*, Jan-Christopher Horak and Joyce Rheuban, translators. In: *October. The Second Decade, 1986–1996*, Cambridge, Massachusetts: MIT Press, 1997, p. 297.

3 Man Ray's film *Two Women* was discovered during the restoration of Ray's films, which was conducted by the Centre George Pompidou, Paris. Ray had clearly planned, produced, and then hidden the film, and as a result the film had never been listed within his filmography. Through careful research, they were able to verify the autorship as Man Ray.

Auf ähnliche Weise sind auch Cantors sexuelle Erfahrungen nicht nur auf die Vorstellung beschränkt. Sie ersetzt die filmische Ellipse bzw. füllt die „Lücke" und löscht damit auch die imaginierte Erotik der Geschichte aus; als Folge müssen sich die Zuschauer mit dem Bild als Tatsache auseinandersetzen, nicht mehr als Ergebnis der eigenen Vorstellungen. Cantor stellt auch den Filmschnitt zur Diskussion, womit die Verwendung/Ausschließung von bestimmtem Material beim Filmemachen und die Art, wie dadurch ein Film zur fiktiven Erzählung, zur erotischen Geschichte oder zur Pornographie wird, angesprochen ist. In *Club Vanessa* bekennt sie sich zur Konstruiertheit der Film/Videobilder, dazu, daß die Textur von Film/Video verwendet wird, um die Fantasie der Zuschauer zwischen Realismus und Imagination hin und her zu steuern, und daß Filmemacher das ästhetische Privileg haben, die Erfahrung der Zuschauer zu bestimmen.

Durch das Verhandeln der privaten Erfahrung der Videoproduktion und die Vorführung der Arbeiten in der Öffentlichkeit tritt Ellen Cantor in einen offenen sexuellen Dialog mit den Zuschauern. Indem sie wiedererkennbare, öffentlich anerkannte Bilder aus dem kommerziellen Kino verwendet und die Arbeiten an öffentlichen Orten (Kunstinstitutionen und Videogalerien) zeigt, setzt sie den ersten Schritt in diesem Austausch, wobei sie das übliche Verhältnis Kunst/Betrachter untergräbt. Durch diese Technik konfrontiert Cantor die Zuschauer mit komplexen Bildern und Geschichten, die über Beziehungen und insbesondere über Sexualität reflektieren. Mit ihren privaten Erfahrungen als Ausgangsmaterial und ästhetischen Techniken, die auf Realismus hinweisen, setzt sie etwas an die Stelle der Ellipse in der Bildsprache des kommerziellen Films, das zu einem filmischen *fait accompli* führt, im Gegensatz zur Anregung der Fantasie.

Cantors Videos erforschen damit die Grenzen zwischen Vorstellung und Realität, zwischen Erotik und Pornographie, zwischen Symbolischem und Faktischem, zwischen dem Öffentlichen und dem Privaten – Dinge, die von zentraler Bedeutung für die Zurschaustellung von Nacktheit und Sexualität in der Kunst und in der Welt sind.

Aus dem Amerikanischen übersetzt von Elisabeth Frank-Großebner

1 John Ellis, *On Photography*, in: *Screen*, vol. 21, Nr. 1 (Frühjahr 1980), S. 103.

2 Gertrud Koch, *Das Schattenreich des Körpers*, hier zitiert in der englischen Übersetzung von Jan-Christopher Horak und Joyce Rheuban. In: *October. The Second Decade, 1986-1996*, Cambridge, Massachusetts: MIT Press, 1997, S. 297.

3 Man Rays Film *Two Women* wurde bei der vom Centre Georges Pompidou durchgeführten Restaurierung seiner Filme in Paris entdeckt. Ray hatte den Film offenbar geplant, produziert und dann versteckt, so daß er nie in der Filmographie aufschien. Durch sorgfältige Recherchen konnte die Urheberschaft von Man Ray verifiziert werden.

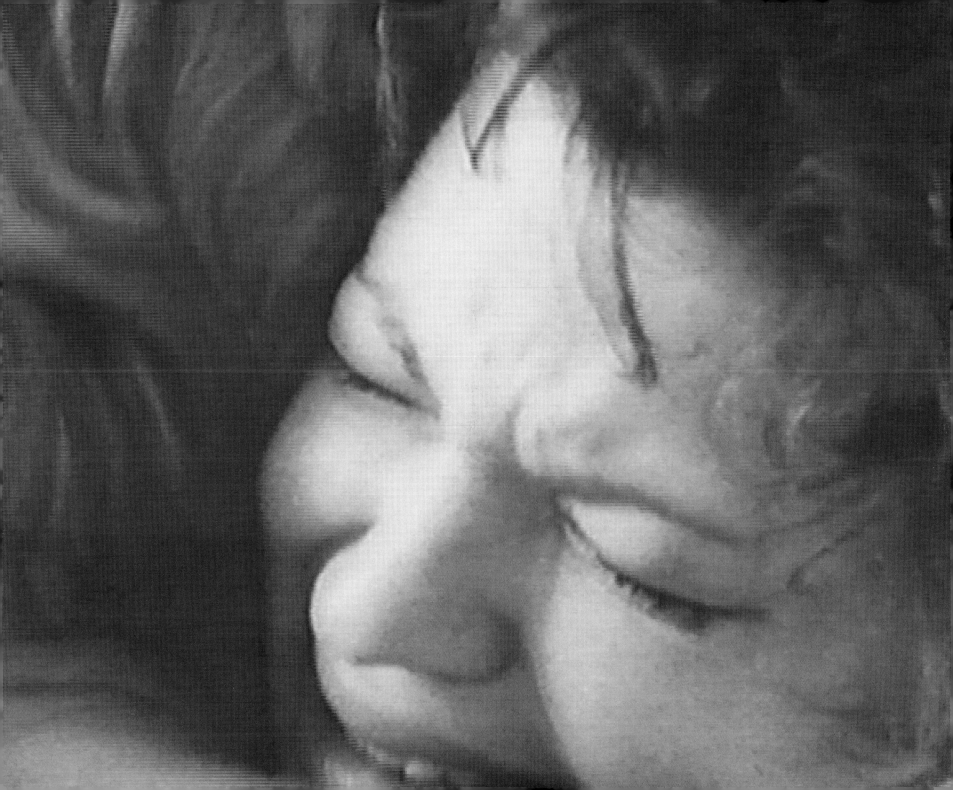

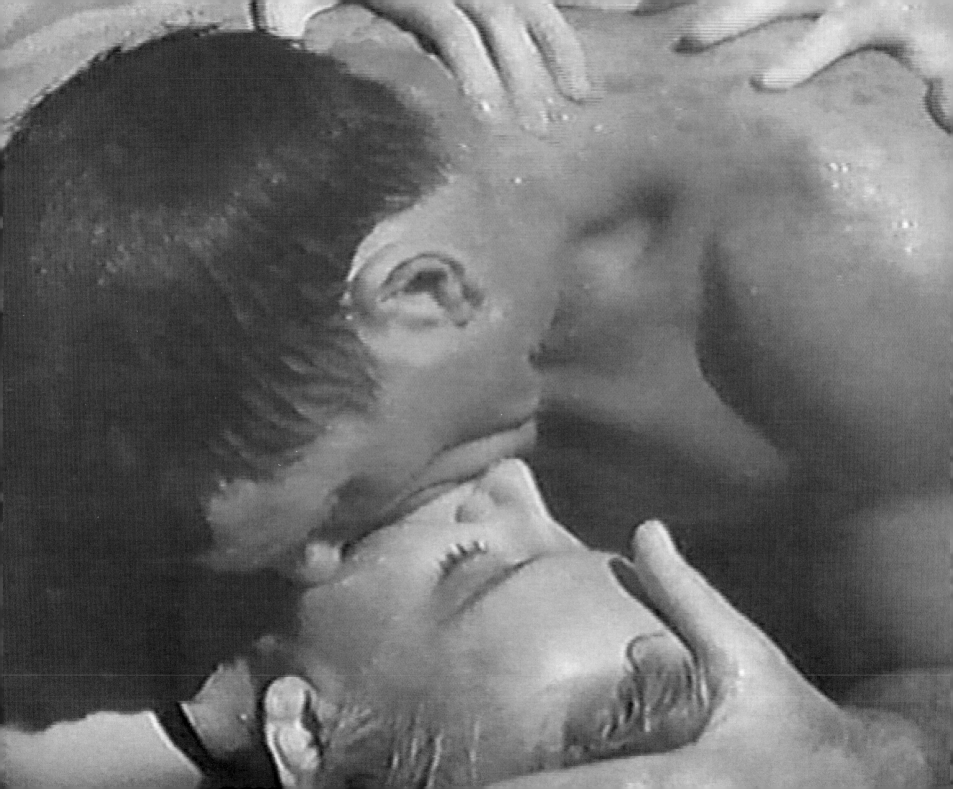

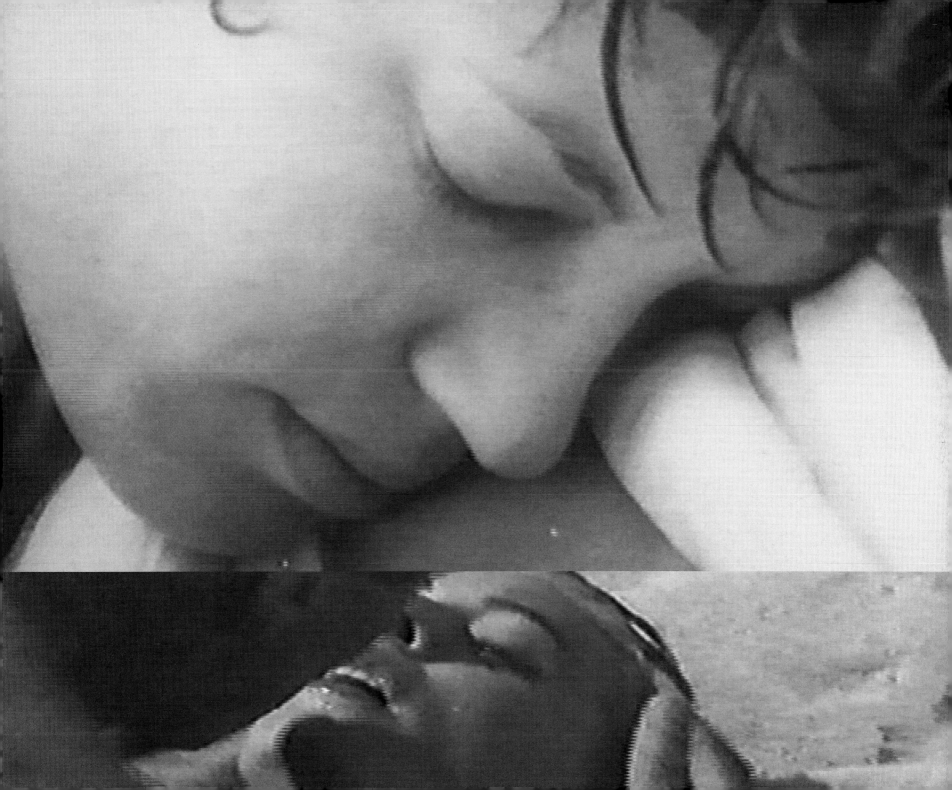

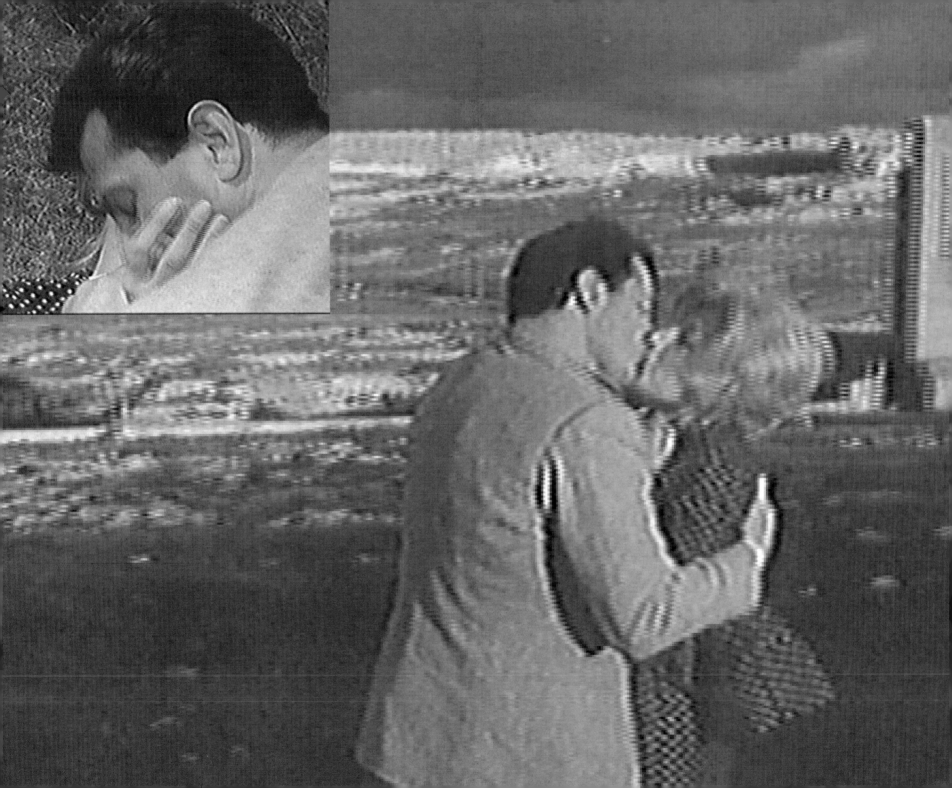

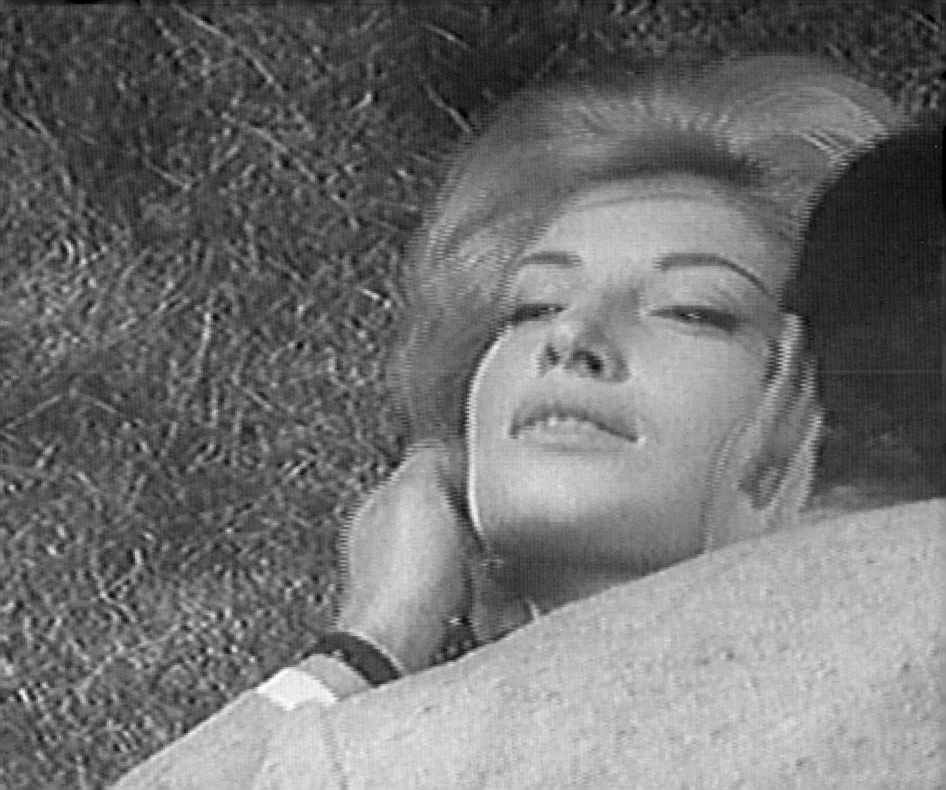

REMEMBER

~~Remember me when I am gone away,~~
~~Gone far away into the silent land;~~
~~When you can no more hold me by the hand,~~
~~Nor I half turn to go yet turning stay.~~
Remember me when no more day by day
 You tell me of our future that you planned:
 Only remember me; you understand
It will be late to counsel then or pray.
Yet if you should forget me for a while
 And afterwards remember, do not grieve:
 For if the darkness and corruption leave
 A vestige of the thoughts that once I had,
~~Better by far you should forget and smile~~
 ~~Than that you should remember and be sad.~~

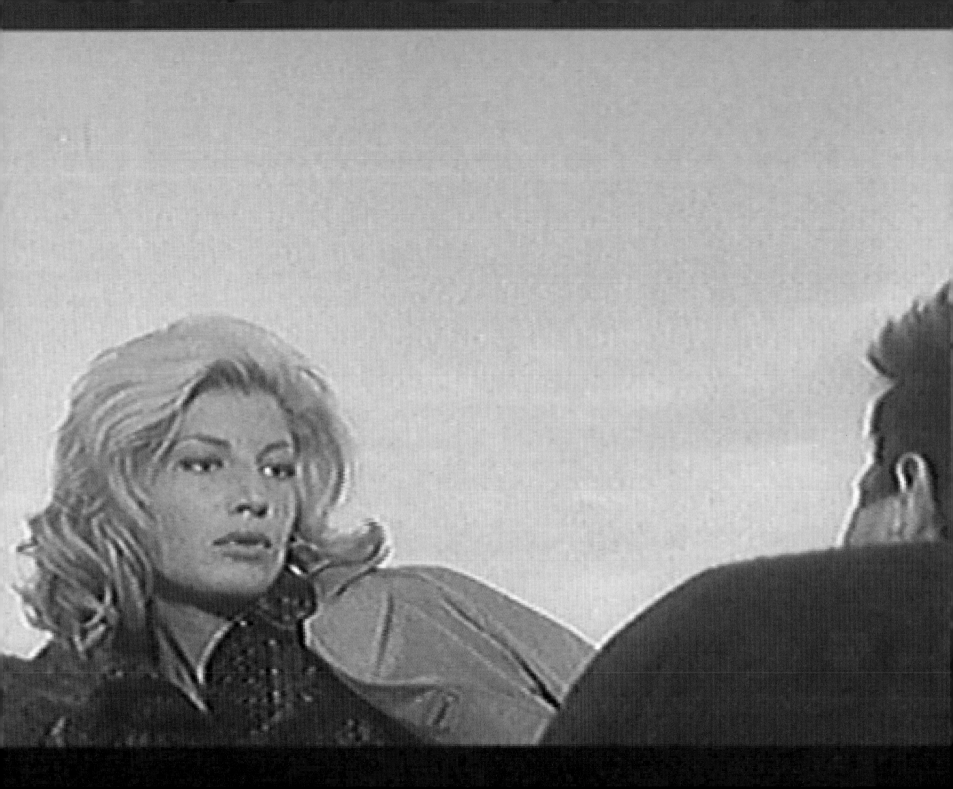

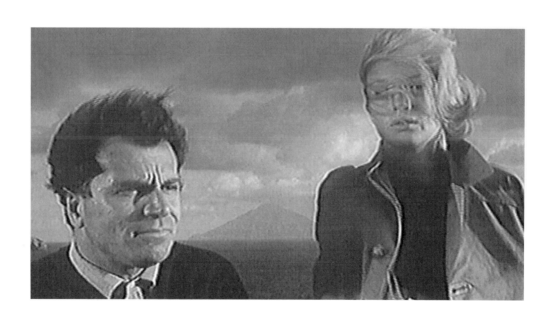

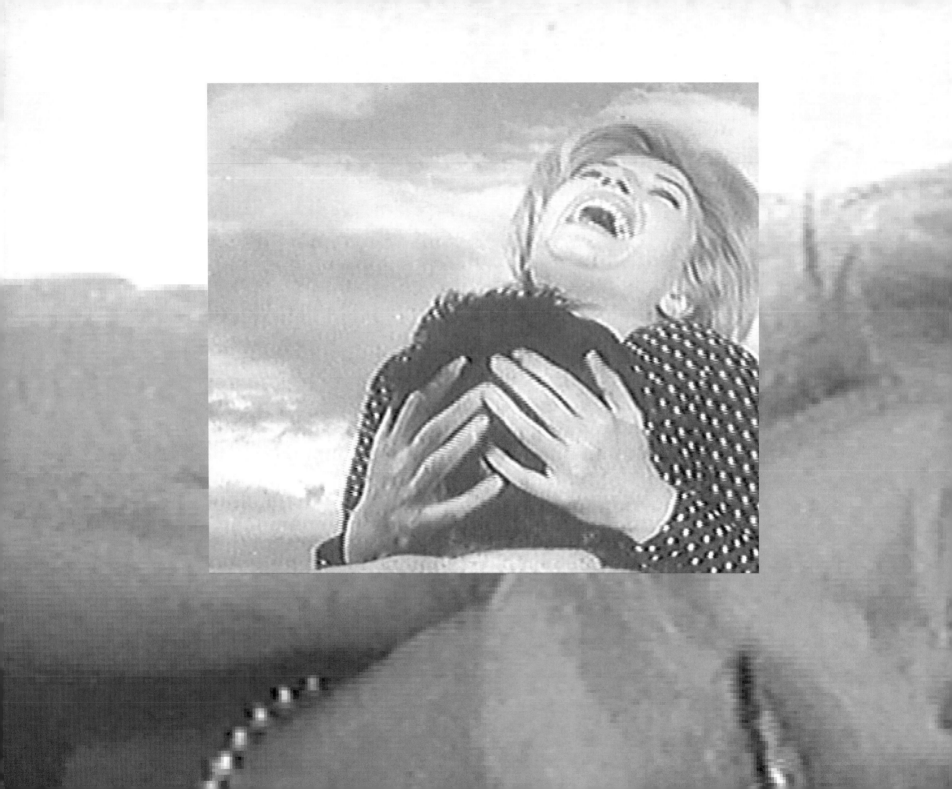

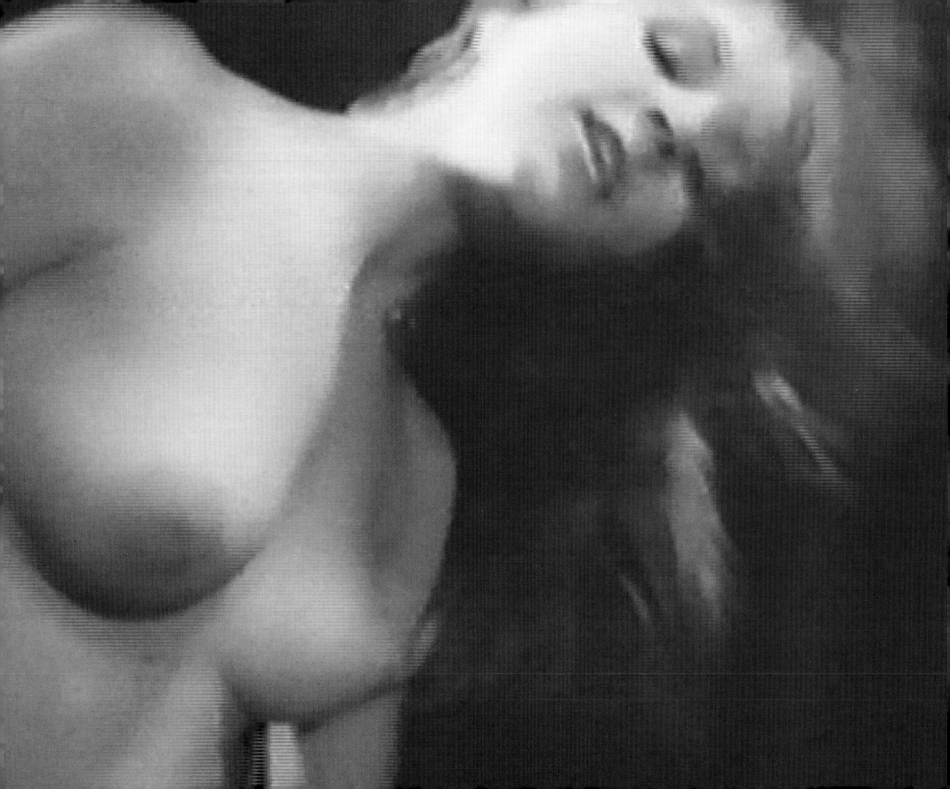

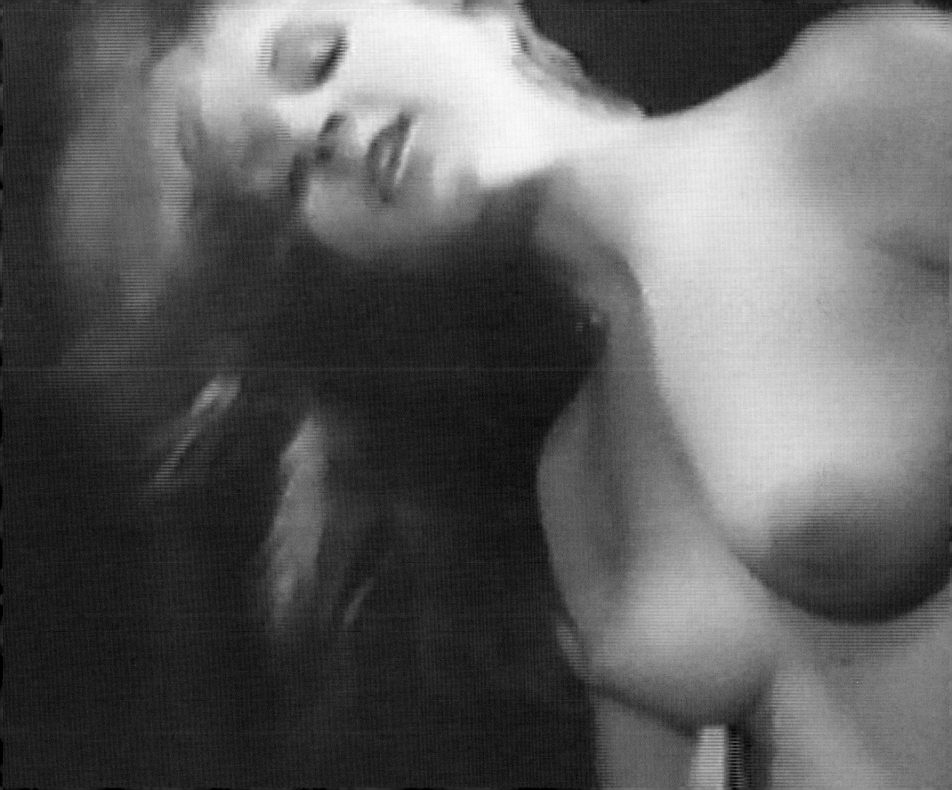

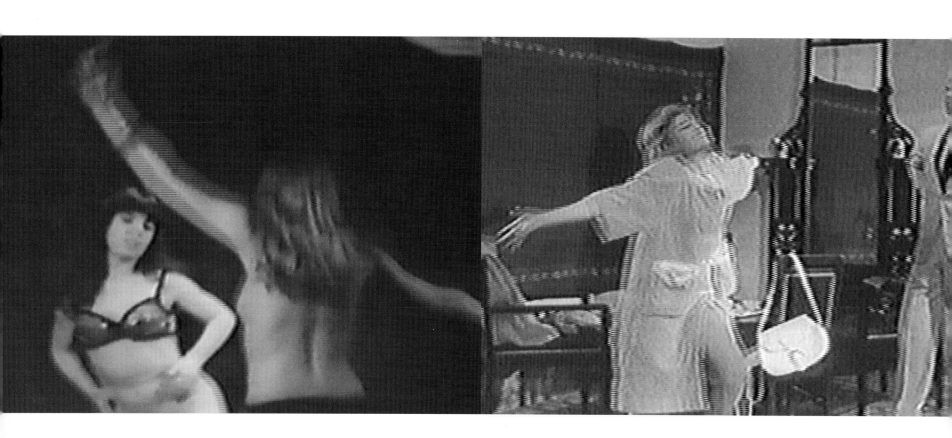

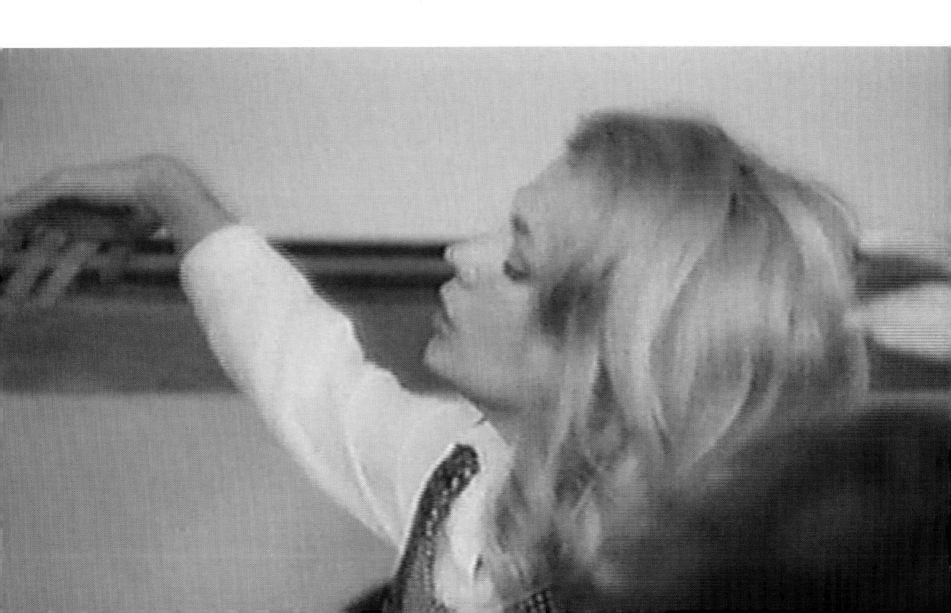

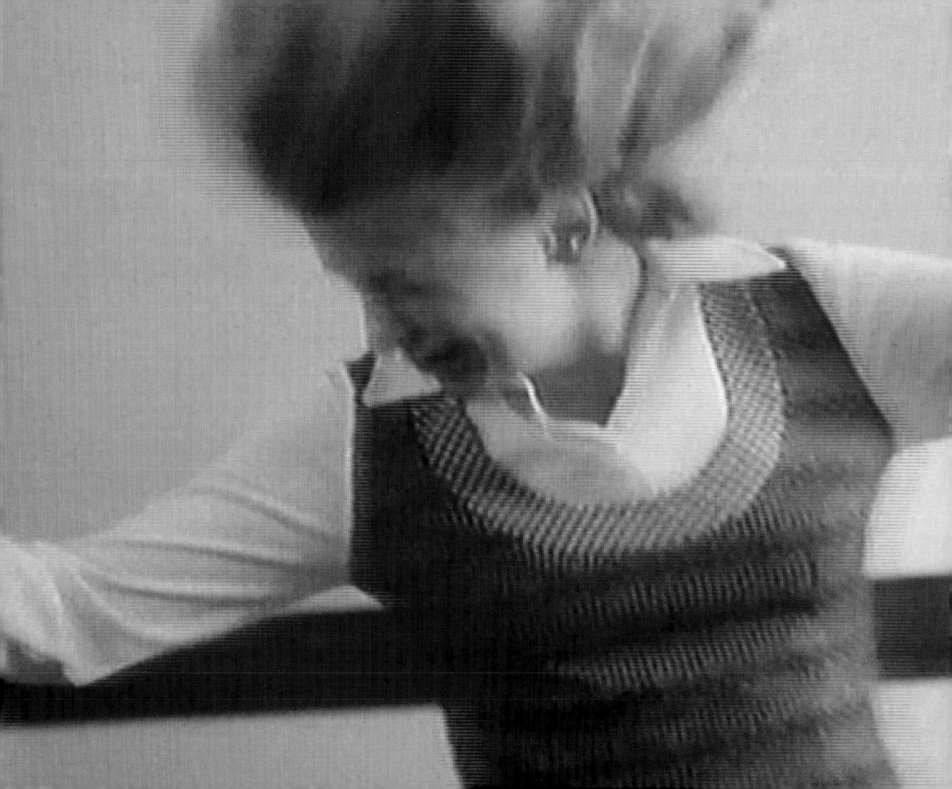

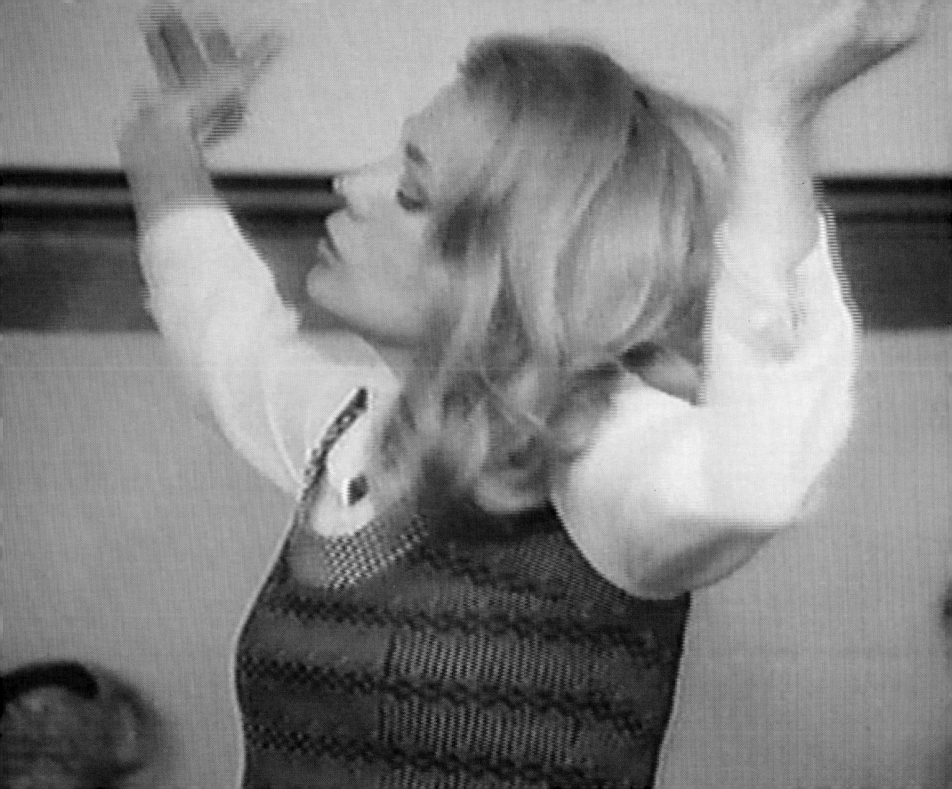

Ellen Cantor

February 14, 1998

Edited by: Eric Schefter

Special Thanks: Mike Sale

Berlin 1998

Y - SO SAD - WHY - SO SAD -WH
Y - SO SAD - WHY - SO SAD -WH
Y - SO SAD - WHY - SO SAD -WH
Y - SO SAD - WHY - SO SAD -WH
Y - SO SAD - WHY - SO SAD -WH
Y - SO SAD - WHY - SO SAD -WH
Y - SO SAD - WHY - SO SAD -WH
Y - SO SAD - WHY - SO SAD -WH
Y - SO SAD - WHY - SO SAD -WH
Y - SO SAD - WHY - SO SAD -WH
Y - SO SAD - WHY - SO SAD -WH
Y - SO SAD - WHY - SO SAD -WH
Y - SO SAD - WHY - SO SAD -WH
Y - SO SAD - WHY - SO SAD -WH
Y - SO SAD - WHY - SO SAD -WH
Y - SO SAD - WHY - SO SAD -WB

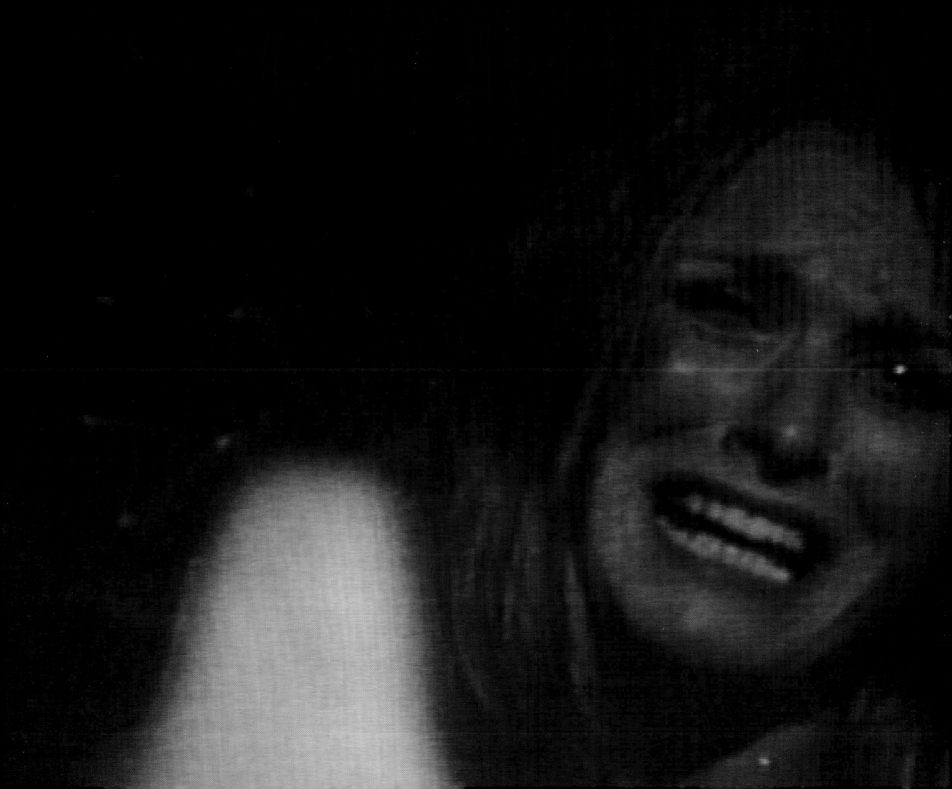

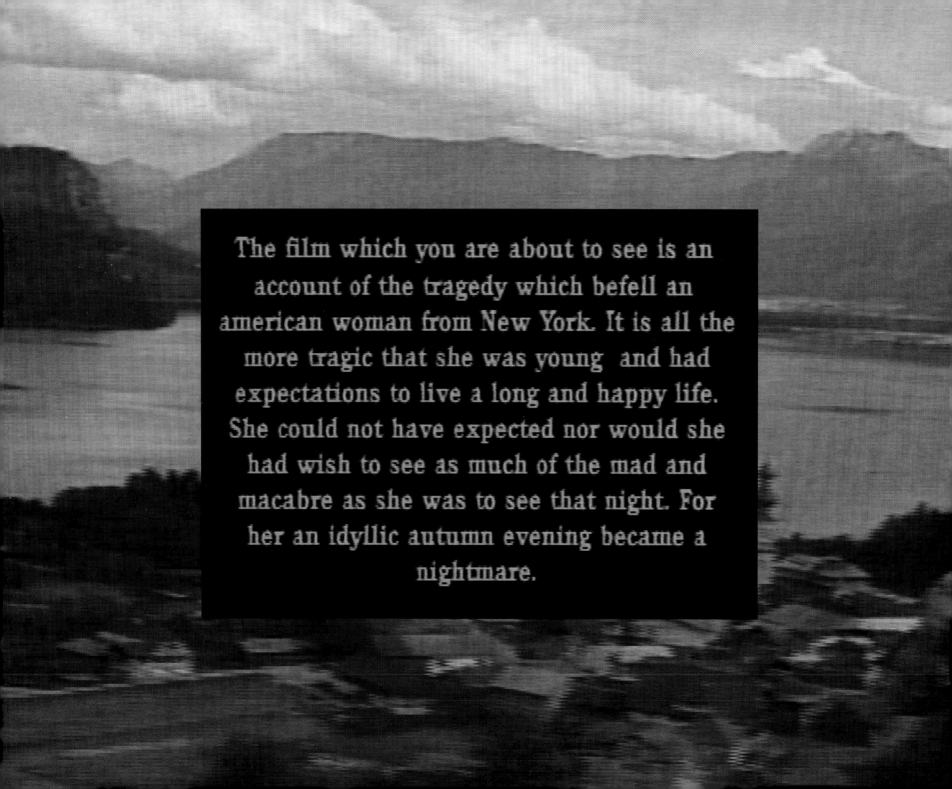

The film which you are about to see is an account of the tragedy which befell an american woman from New York. It is all the more tragic that she was young and had expectations to live a long and happy life. She could not have expected nor would she had wish to see as much of the mad and macabre as she was to see that night. For her an idyllic autumn evening became a nightmare.

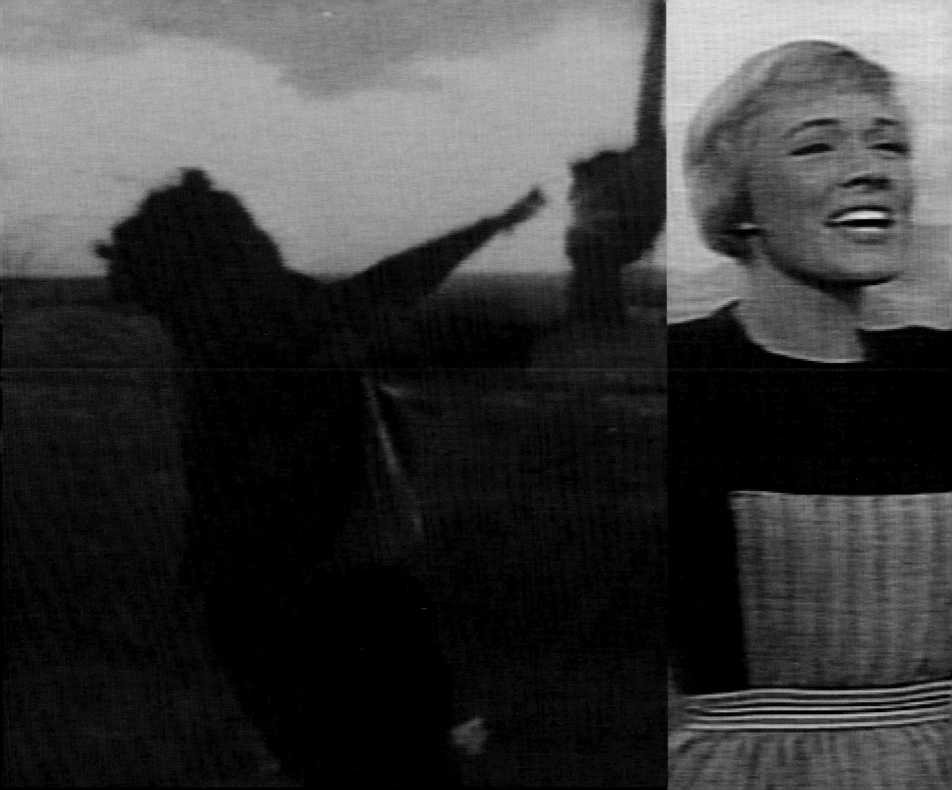

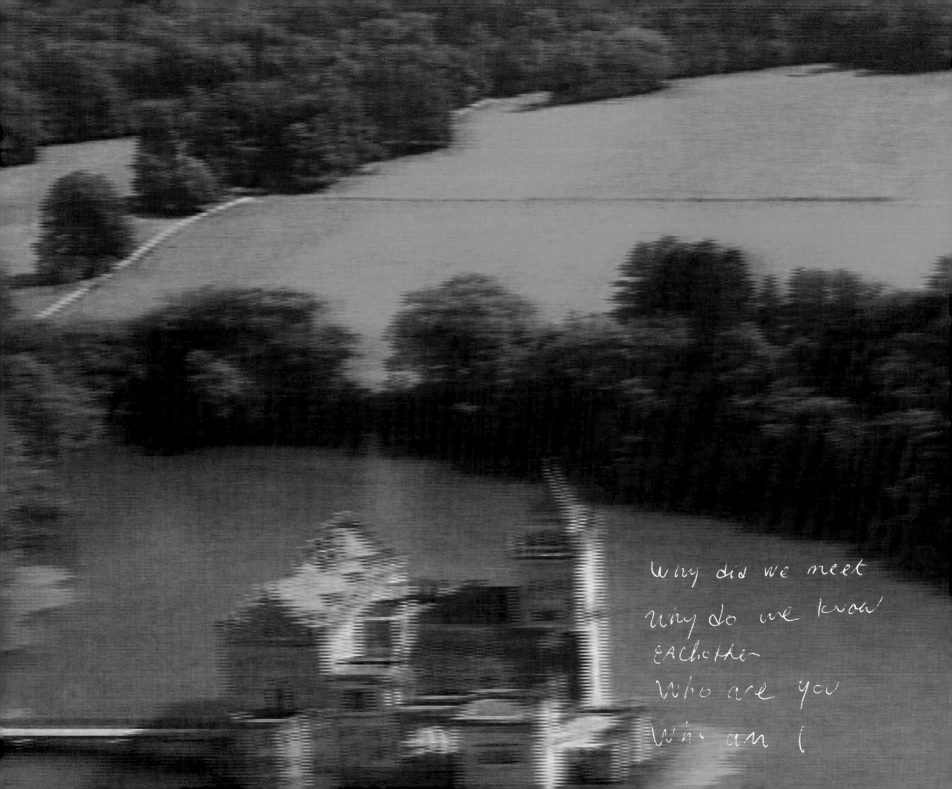

Why did we meet
why do we know
eachother
Who are you
Who am i

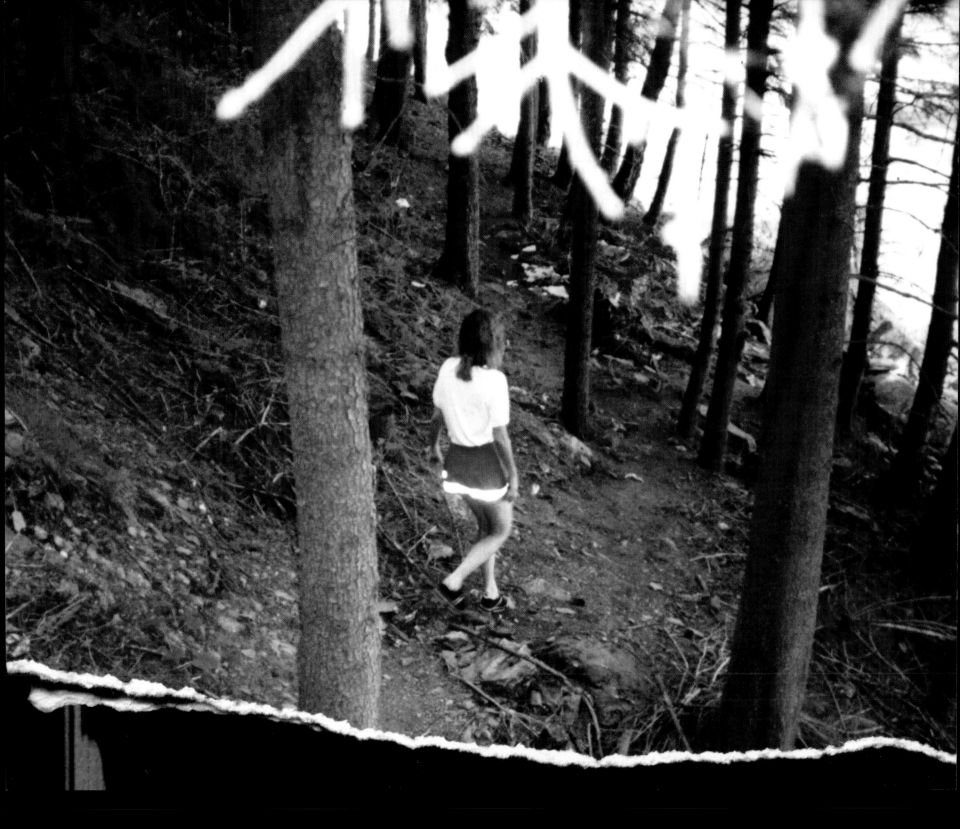

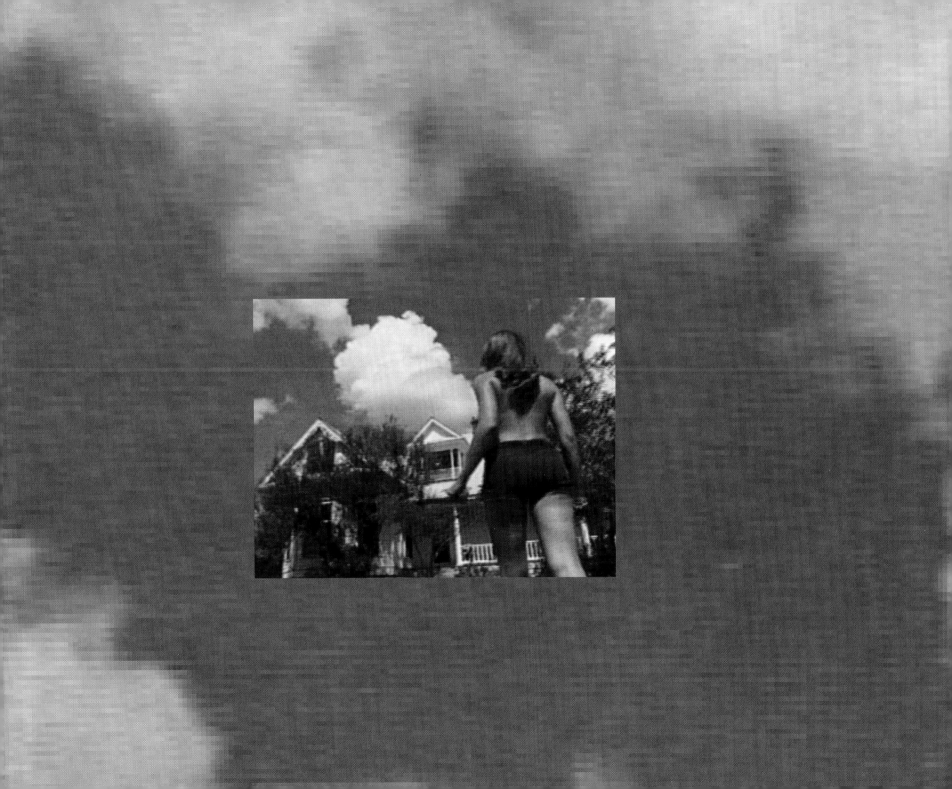

I said you love
me too much &
you said its
true & you were
kissing me again
& again asking
when you'd see me
& you had my shirt
off outside next to
the tran feeling
my breasts
we were so much in
our own dream
we just didnt
gotta know there was
any other world

you said you were
proud of me that I was
so stung & its started
me almost crying because
its almost true by now
& I've hurtso

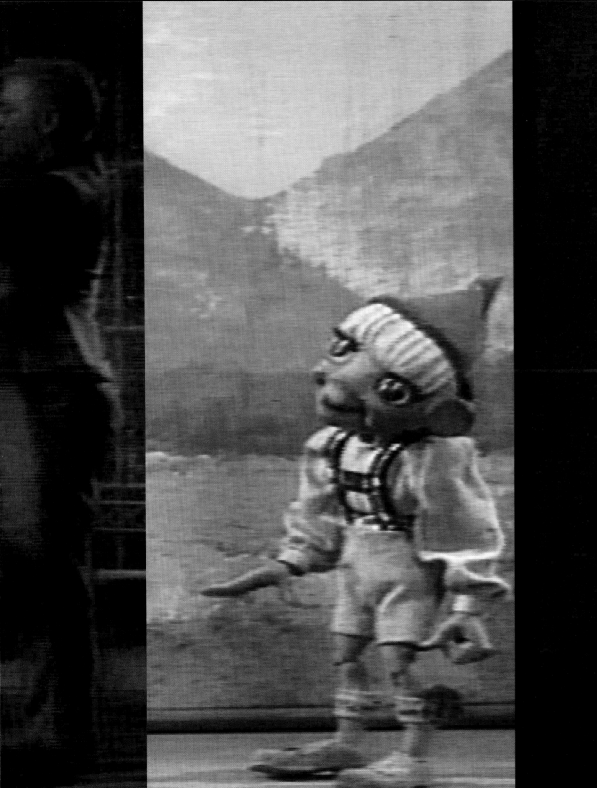

Aviva says this man
is insane, he is ill,
if you stay... for sure
he will kill you
one day. He is a
murderer.

you can walk away.

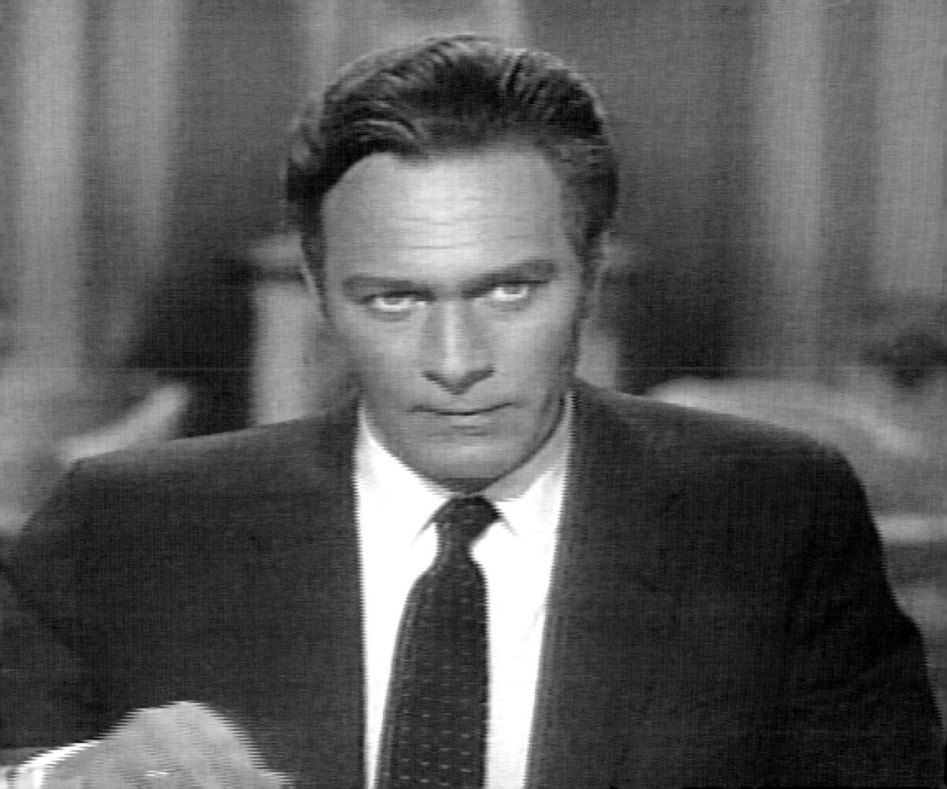

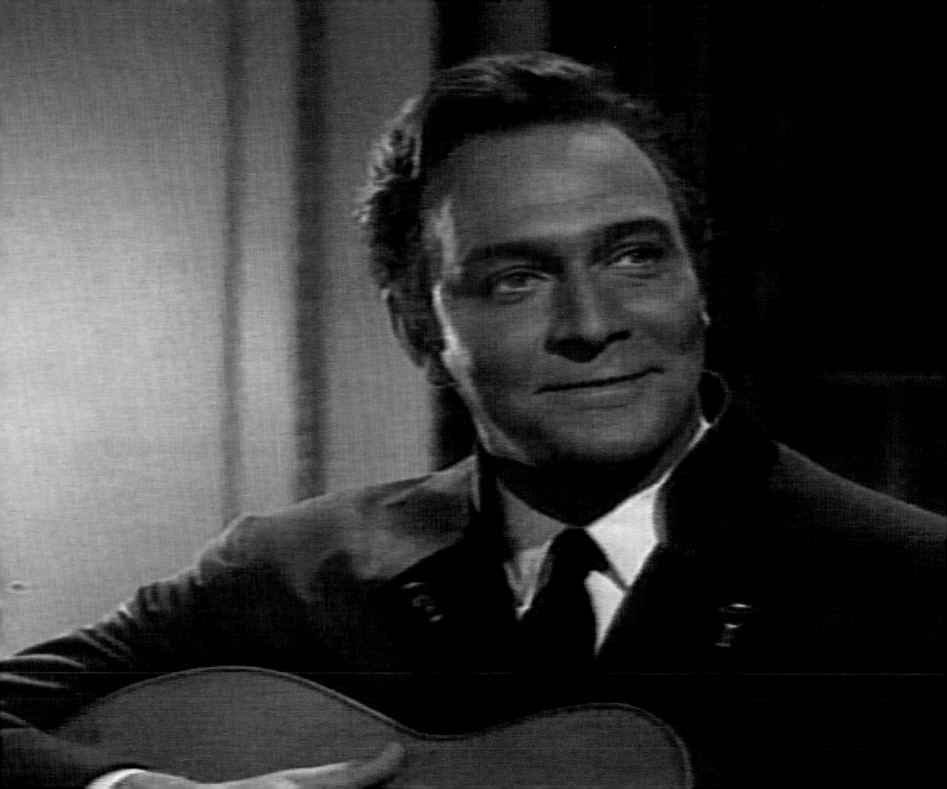

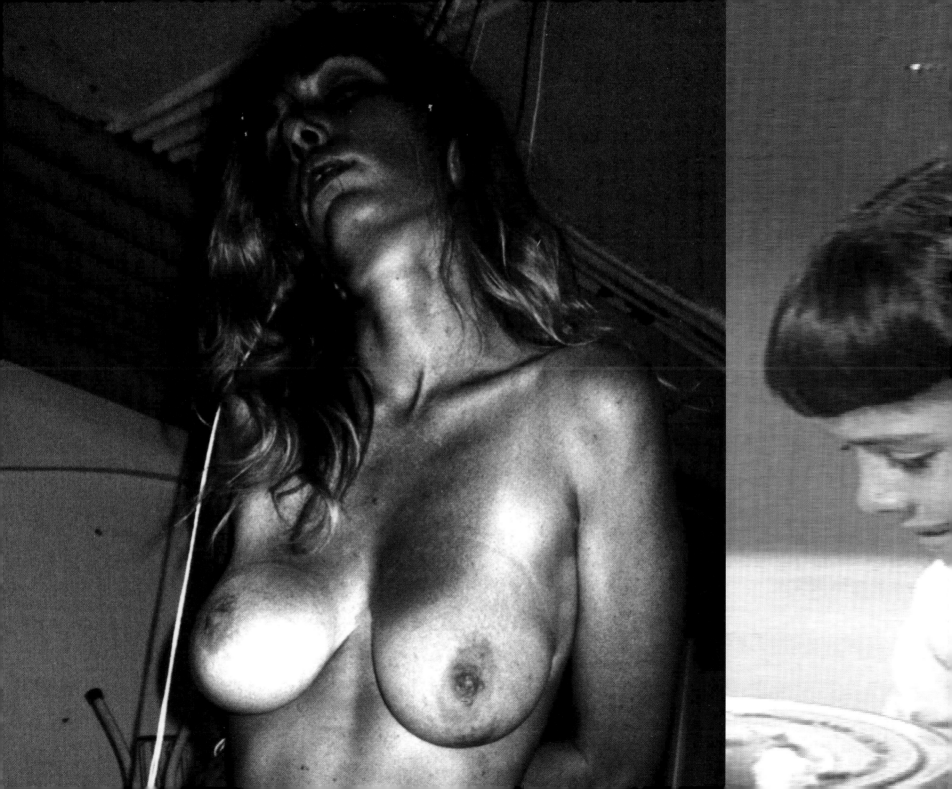

why c'd he desire to murde

why do we love eachother

so c

when we first
watched the ...
Clarisse Har...
I was crying
he said, this was his
... good. If only
he could murder,
only ... he lacked
courage

I thought who is this
man I love.

saw eachother – it happen a long
time & you knew everywhere I'd been
I mean it was an & everything
accident – but we were
still in love – of course

really on purpose
when we met you said
you were going to murder
me – & I was well
this felt really ok with
me I was tired of trying so hard &
I wanted to die in your hands
we had been battling
so much up (story of susies side)

& you started to try &
kill me & I was completely
compliant

but I was stressing too
& you were really
hunting me completely
out of your head & we the rope bride

were laughing so hard

like all our
dreams were coming true

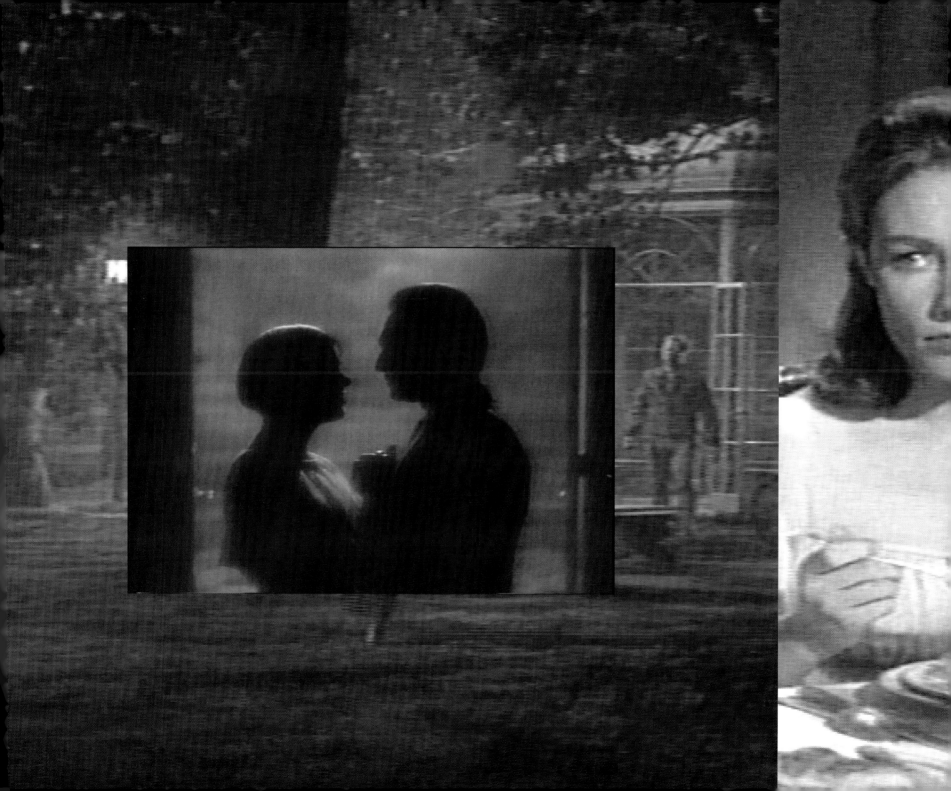

he was helping me
& telling me about Tina
Turner on something
like shatters
& i was freaking out
& then he turned out
to be a super freak
then he was trying to
fuck me
& I was pushing him away
& he started to scream at
me that I loved
you more than
which was pretty wild
him & that I was
a whore a
whatever
it was a very
very bad trip
& I wish instead you
had saved me from him

he
told
me
it's
the
day
all
my
dreams
came
true
& that
I should
trust
him to
help me
with friendship
money whatever

to me
since you don't usually
that mail people with
pictures of yourself
but you hadn't really thought
this through & you were
getting nervous &
I said I was confused
& they.....
well
I guess it was like you
— murdered me
hadn't
but this time I didn't be
expect to die

I do think it WAS it
anything
& I can't imagine it give we
you much pleasure either
I was screaming the too
but we were outside
& it wasn't very funny
this man came to save me
& he said I couldn't call the
police because I was a foreigner

you
just
lost
it

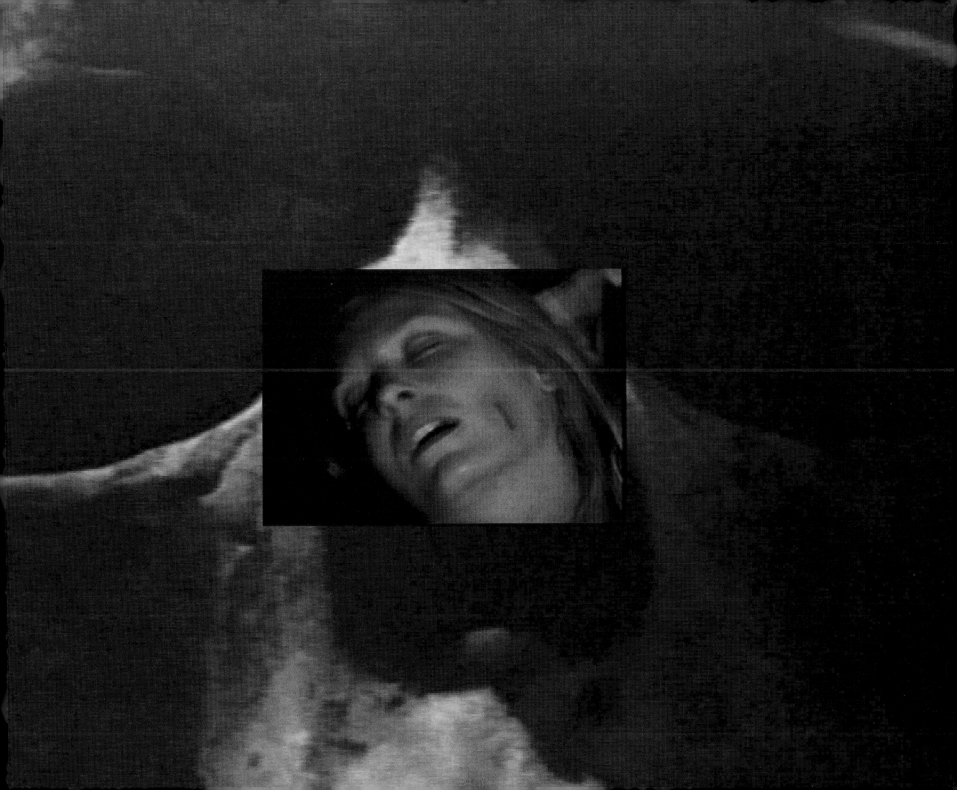

WHY - SO SAD - WHY - SO SAD - WHY - SO SAD - WHY - SO SAD - WHY - SO SAD -
WHY - SO SAD - WHY - SO SAD - WHY - SO SAD - WHY - SO SAD - WHY - SO SAD -
WHY - SO SAD - WHY - SO SAD - WHY - SO SAD - WHY - SO SAD - WHY - SO SAD -
WHY - SO SAD - WHY - SO SAD - WHY - SO SAD - WHY - SO SAD - WHY - SO SAD -
WHY - SO SAD - WHY - SO SAD - WHY - SO SAD - WHY - SO SAD - WHY - SO SAD -
WHY - SO SAD - WHY - SO SAD - WHY - SO SAD - WHY - SO SAD - WHY - SO SAD -
WHY - SO SAD - WHY - SO SAD - WHY - SO SAD - WHY - SO SAD - WHY - SO SAD -
WHY - SO SAD - WHY - SO SAD - WHY - SO SAD - WHY - SO SAD - WHY - SO SAD -
WHY - SO SAD - WHY - SO SAD - WHY - SO SAD - WHY - SO SAD - WHY - SO SAD -
WHY - SO SAD - WHY - SO SAD - WHY - SO SAD - WHY - SO SAD - WHY - SO SAD -
WHY - SO SAD - WHY - SO SAD - WHY - SO SAD - WHY - SO SAD - WHY - SO SAD -
WHY - SO SAD - WHY - SO SAD - WHY - SO SAD - WHY - SO SAD - WHY - SO SAD -
WHY - SO SAD - WHY - SO SAD - WHY - SO SAD - WHY - SO SAD - WHY - SO SAD -
WHY - SO SAD - WHY - SO SAD - WHY - SO SAD - WHY - SO SAD - WHY - SO SAD -
WHY - SO SAD - WHY - SO SAD - WHY - SO SAD - WHY - SO SAD - WHY - SO SAD -
WHY - SO SAD - WHY - SO SAD - WHY - SO SAD - WHY - SO SAD - WHY - SO SAD -
WHY - SO SAD - WHY - SO SAD - WHY - SO SAD - WHY - SO SAD - WHY - SO SAD -
WHY - SO SAD - WHY - SO SAD - WHY - SO SAD - WHY - SO SAD - WHY - SO SAD -
WHY - SO SAD - WHY - SO SAD - WHY - SO SAD - WHY - SO SAD - WHY - SO SAD -
WHY - SO SAD - WHY - SO SAD - WHY - SO SAD - WHY - SO SAD - WHY - SO SAD -
WHY - SO SAD - WHY - SO SAD - WHY - SO SAD - WHY - SO SAD - WHY - SO SAD -
WHY - SO SAD - WHY - SO SAD - WHY - SO SAD - WHY - SO SAD - WHY - SO SAD -
WHY - SO SAD - WHY - SO SAD - WHY - SO SAD - WHY - SO SAD - WHY - SO SAD -
WHY - SO SAD - WHY - SO SAD - WHY - SO SAD - WHY - SO SAD - WHY - SO SAD -
WHY - SO SAD - WHY - SO SAD - WHY - SO SAD - WHY - SO SAD - WHY - SO SAD -
WHY - SO SAD - WHY - SO SAD - WHY - SO SAD - WHY - SO SAD - WHY - SO SAD -
WHY - SO SAD - WHY - SO SAD - WHY - SO SAD - WHY - SO SAD - WHY - SO SAD -
WHY - SO SAD - WHY - SO SAD - WHY - SO SAD - WHY - SO SAD - WHY - SO SAD -
WHY - SO SAD - WHY - SO SAD - WHY - SO SAD - WHY - SO SAD - WHY - SO SAD -
WHY - SO SAD - WHY - SO SAD - WHY - SO SAD - WHY - SO SAD - WHY - SO SAD -
WHY - SO SAD - WHY - SO SAD - WHY - SO SAD - WHY - SO SAD - WHY - SO SAD -
WHY - SO SAD - WHY - SO SAD - WHY - SO SAD - WHY - SO SAD - WHY - SO SAD -

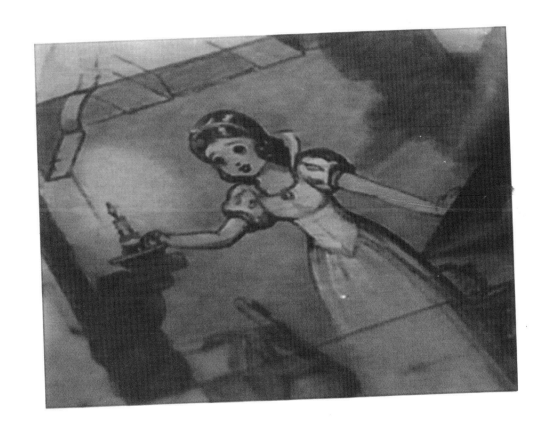

Your Texas - Chain - Saw - Sound - Of - Music
Motherfucker

Co-Director: Mario Herrera
Edited by: Roger Acosta
NYC 1996

100 million are killers 100 million are guard

and 100 million are capable of fertilization

Ode to Life
(Minuet in G Major)
by Ellen Cantor

Edited by: Roger Acosta
Special Thanks: Mario Herrera, Uscha Pohl
NYC 1997

Club Vanessa

MORE!

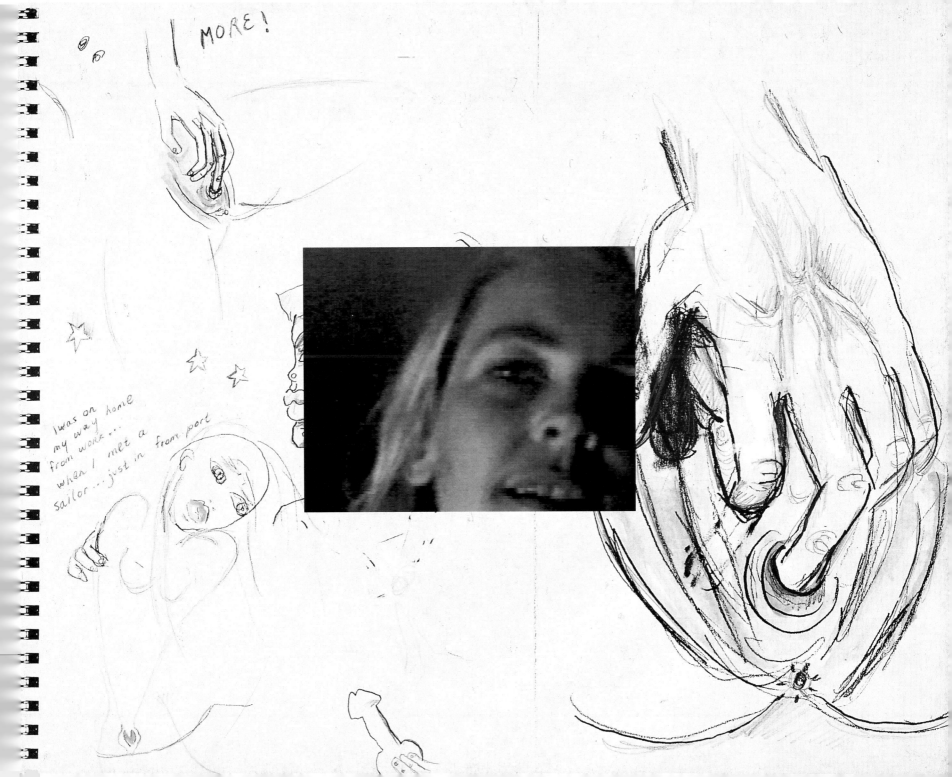

I was on home
my way
from work...
when I met a
sailor...just in from port

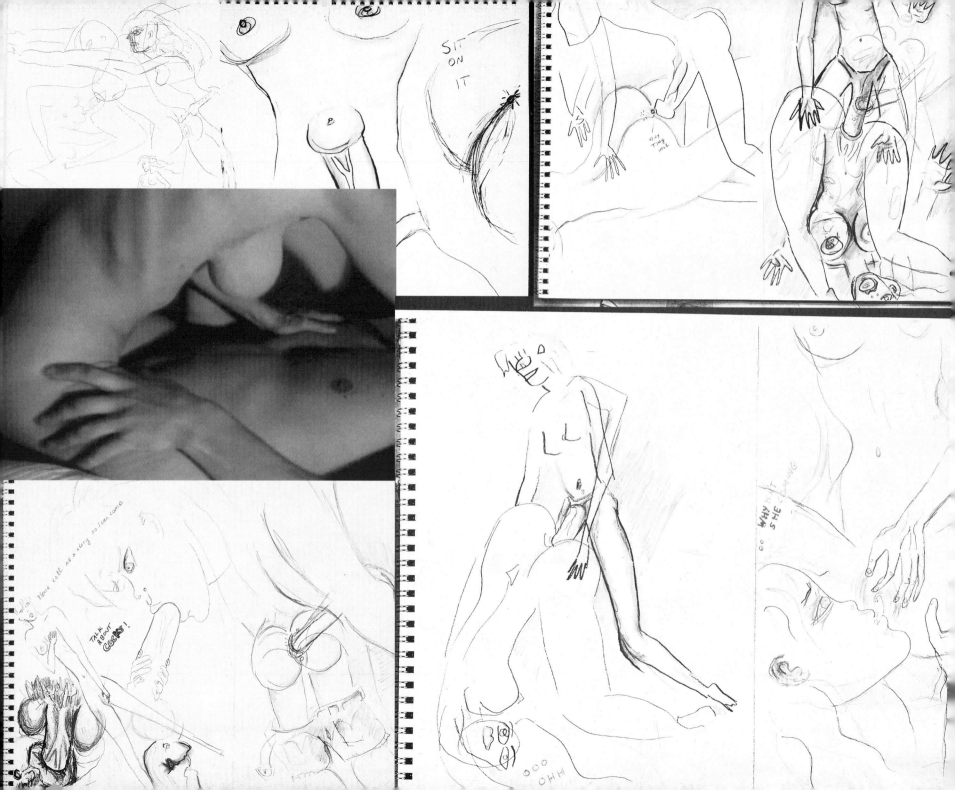

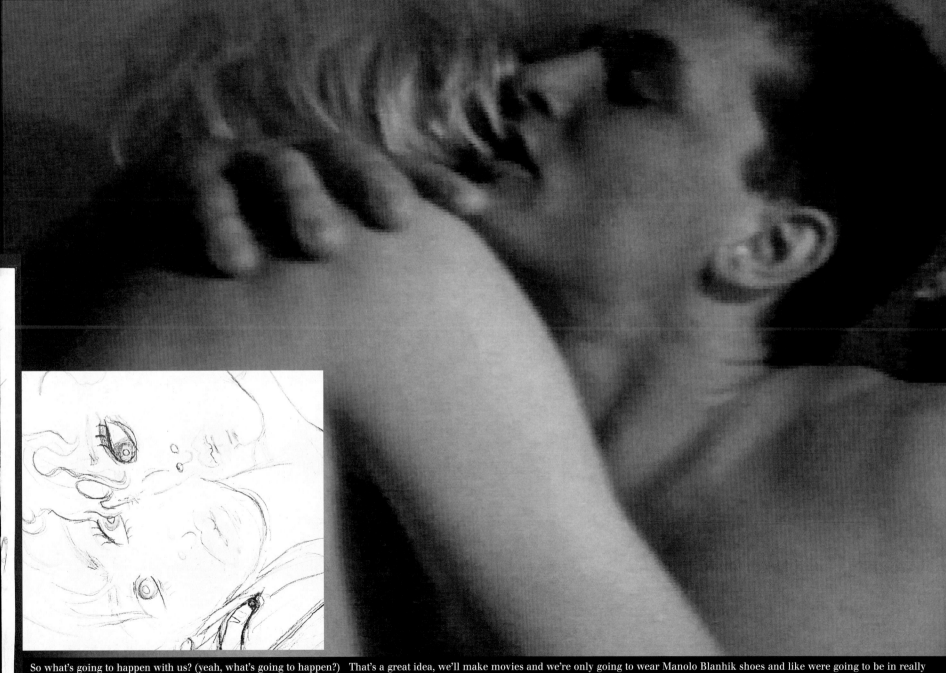

So what's going to happen with us? (yeah, what's going to happen?) That's a great idea, we'll make movies and we're only going to wear Manolo Blanhik shoes and like were going to be in really good shape because we do yoga all the time and we'll wear string bikinis wherever we go. But then like everywhere we go we have lovers ... people that we're really in love with and that they really love us too. And ... we'll make love with them and it will be like real love like it REALLY will be love, but there won't be any jelousy. And at the end you say I'm going to be busy this week, I'll see you next week -- and they say great. And it's so nice.
It's real love. And we call it Club Vanessa.

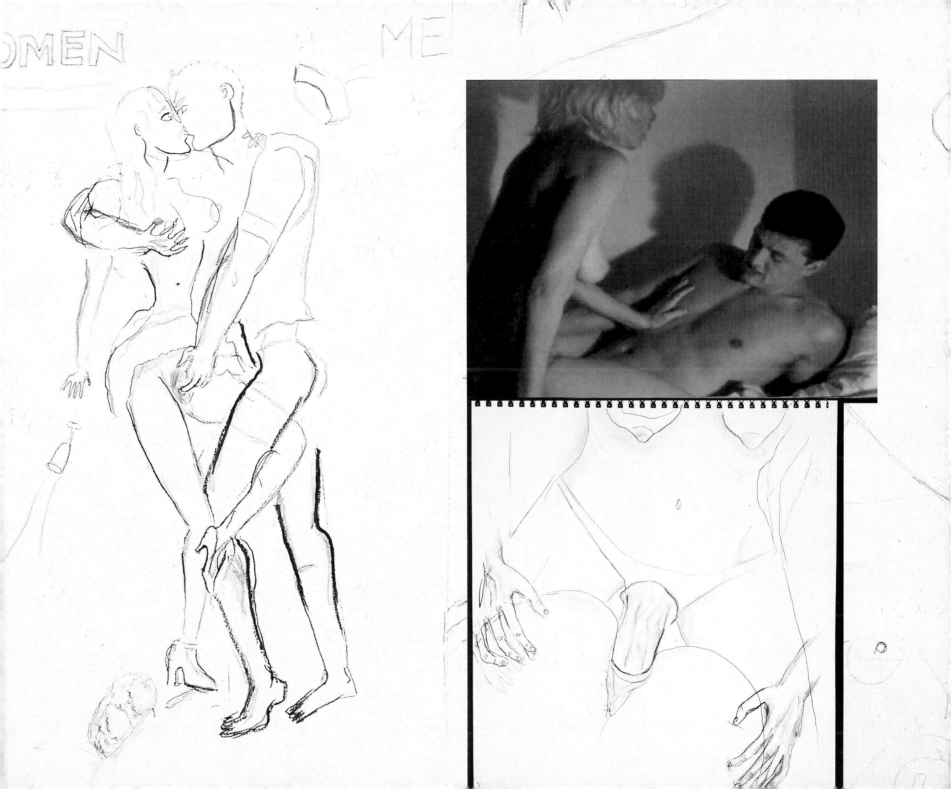

She suddenly realized she was in the right place.

Closely Assisted by: Veronica Vega

NYC 1996

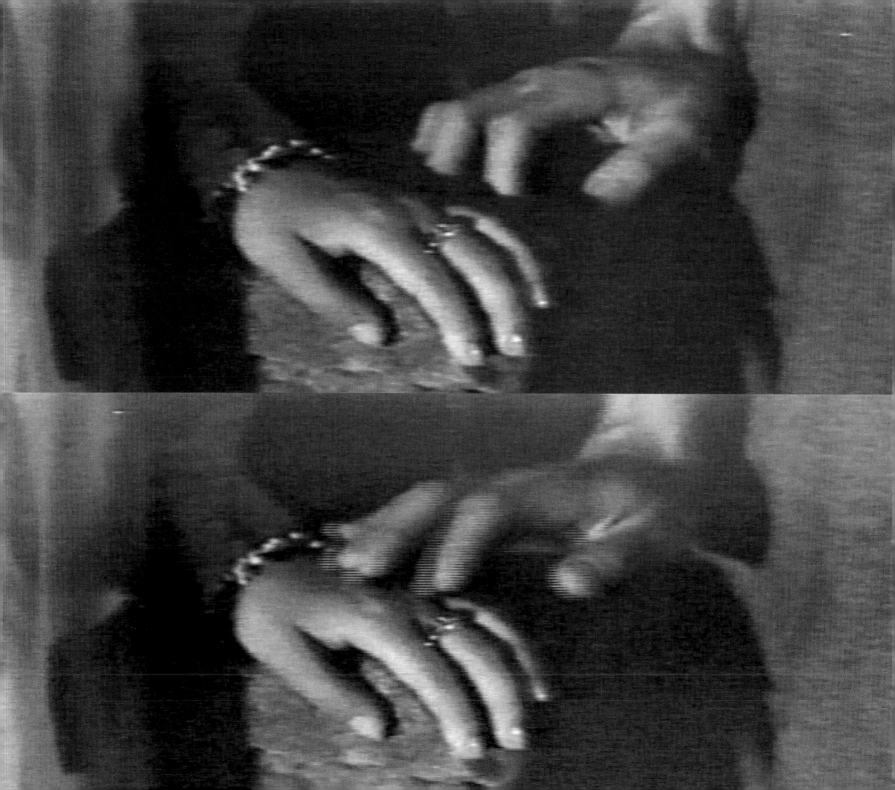

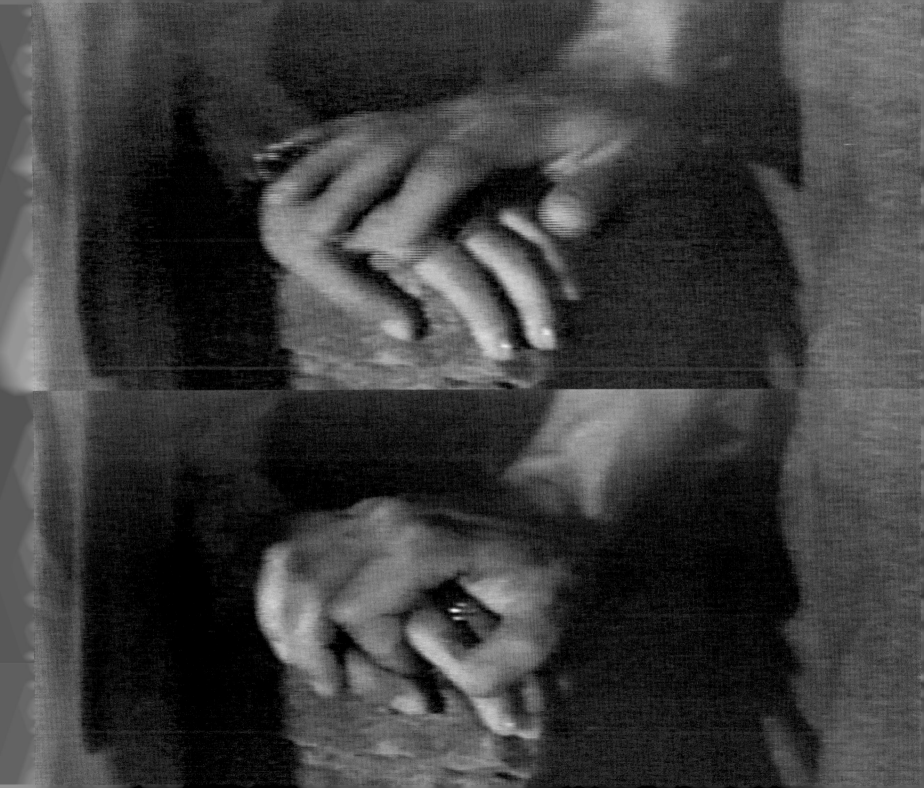

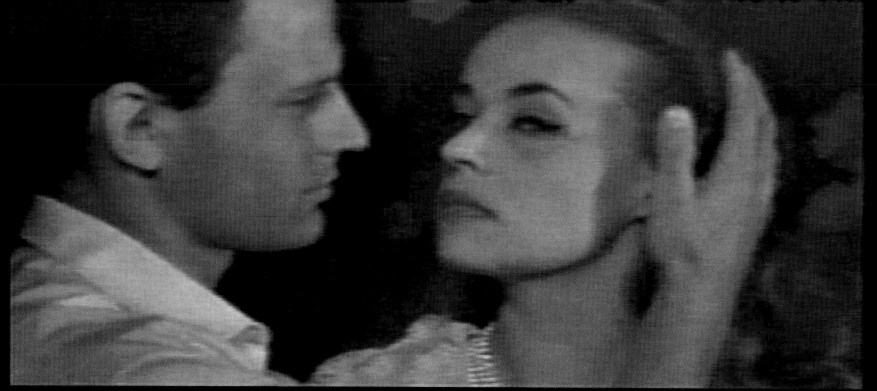

Love can be born in a glance

In an instant, Jeanne felt all shame
and restraint die away

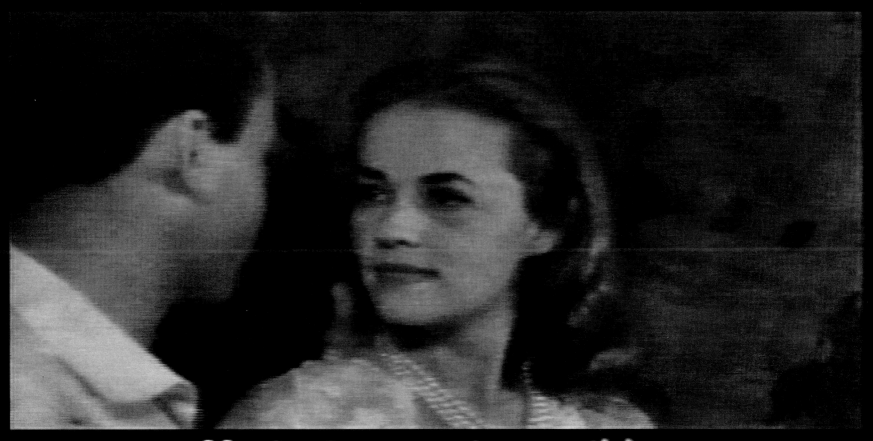

Hesitation was impossible;
one does not resist happiness

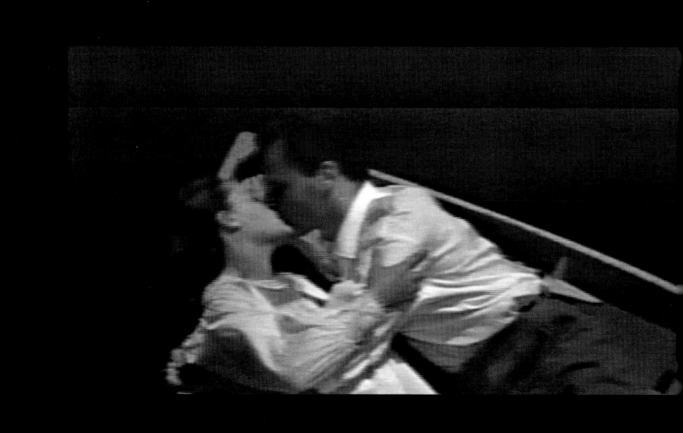

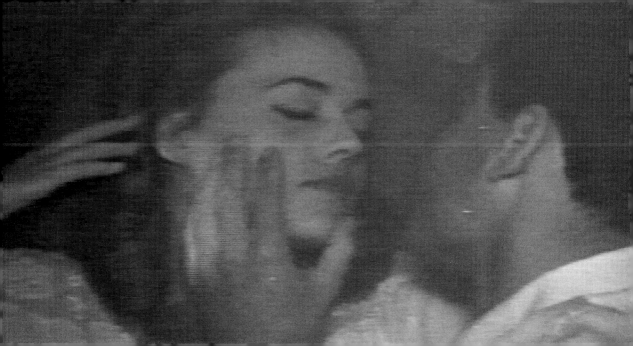

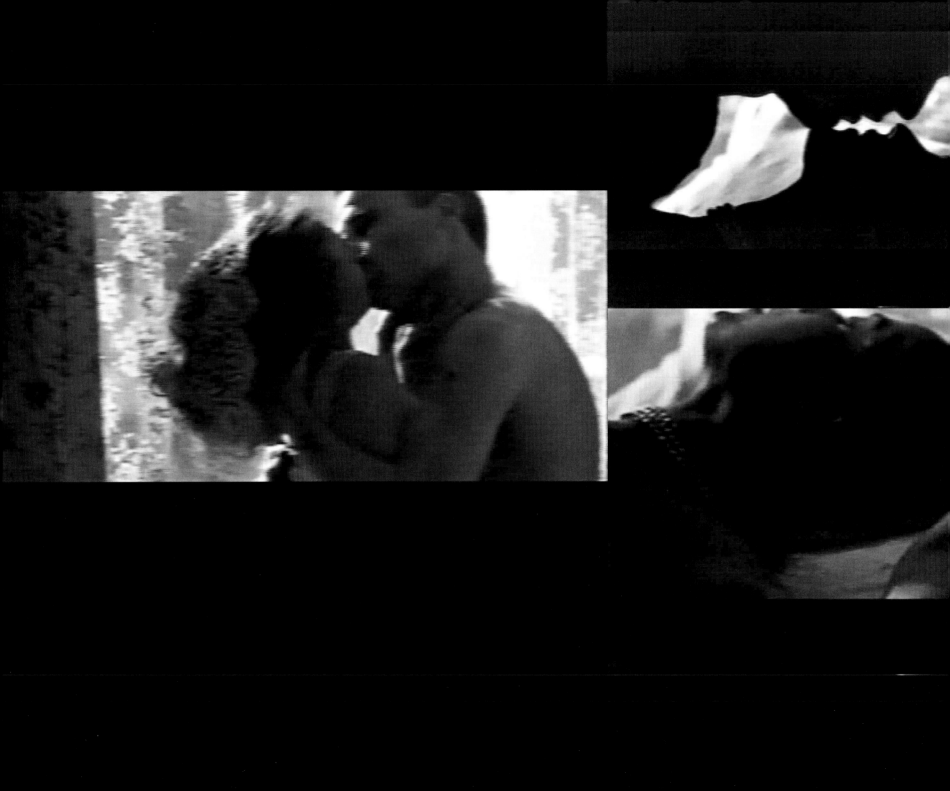

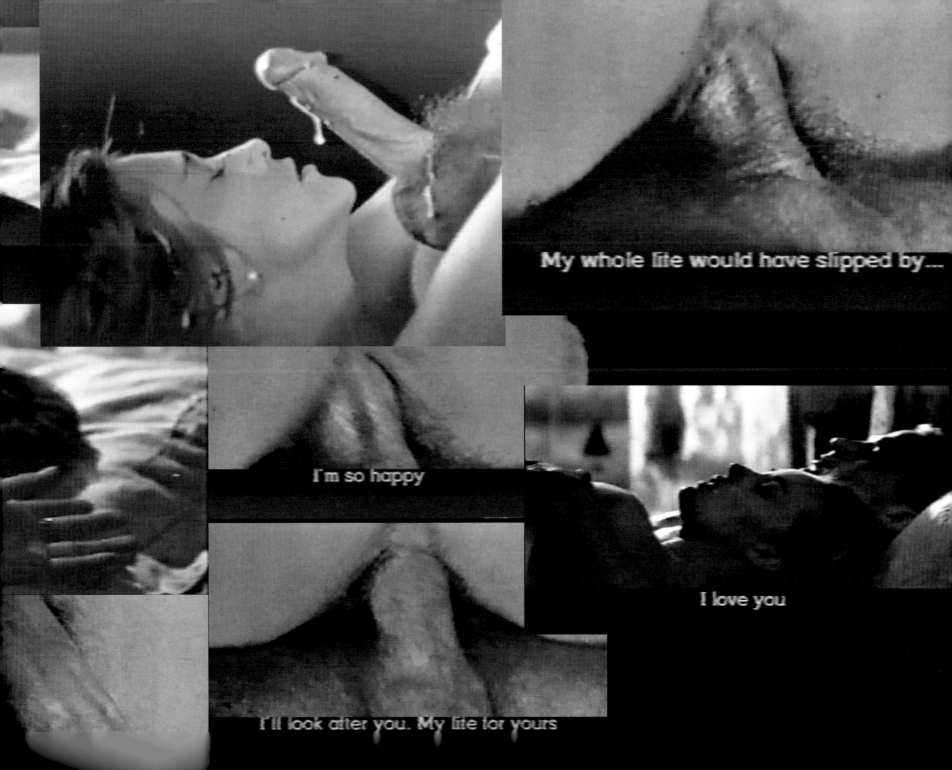

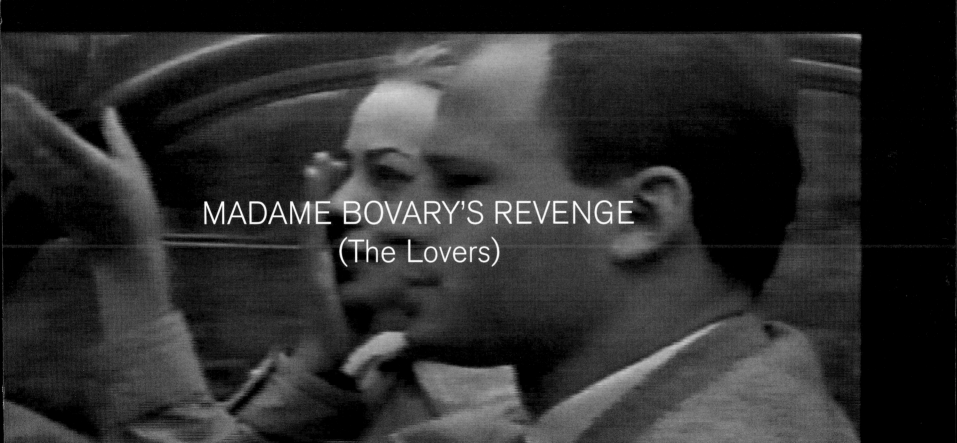

Assistant Director: Veronica Vega
NYC 1995

Gerald Matt: Your video, *Within Heaven and Hell*, includes footage from *The Texas Chainsaw Massacre*, a film where there is terror, fear and other very uncomfortable feelings; and at the same time *The Sound of Music* is involved. These pictures of good and happy family life, of people of high moral values leaving their country for their ideals – a certain cliché of Austria, but also probably a cliché of the old world. What was your intention in placing this cliché of Austria in this bloody context of *The Chainsaw Massacre*? Is there any biographical background?

Ellen Cantor: Both films, *The Sound of Music* and *The Texas Chainsaw Massacre* are based on true stories. *The Sound of Music*, a musical about the Von Trapp family was made in the Sixties. In America and Britain people are in love with this film. I saw it when I was a child may be 100 times, may be more. Everyone used to play games with *The Sound of Music*, singing, play-acting …

Whenever you speak to people in the States about their view of Austria, it was influenced by this film.

I think this relates to the pervasive spirit in the country when I grew up in the Sixties. We used to stand in the driveway …

Outside Detroit.

… and my brothers would unfold and hoist the flag, and my family would say the pledge of allegiance. There really was this idealism at the time, that this society was going to create a free world, with perfect love and perfect democracy. This is a vision I grew up with, a sense of innocence and possibilities in the world.

Subsequently, *The Texas Chainsaw Massacre*, a horror film based on the serial killer Ed Gein, was made in the Seventies. It's a very dark view of family life – humanity. In my opinion, it is so well done, so terrible, that it supersedes the horror film genre, becoming mythological like a Pasolini film. I think that this film in reality relates to the shift in the American vision. Because what happened as the Sixties were preceding was we entered the Vietnam War. The Country was also at war with itself – for civil rights, for the atrocities the government was committing. Many people were opposed to fighting in this war. The actual violence was shown on television every day. So this vision of innocence was really falling apart.

I come to Europe and I know this is a place where there has been complete human destruction. Simultaneously, I'm coming from a country where there has been degradation to humanity, and then there is the devastation in Yugoslavia and Bosnia and hundreds and thousands of rapes taking place.

And there is a sense as an adult, why is this happening? There is no way to get away from it – everywhere around you is perpetual violence, and it's on a personal level also. Still retaining this vision you grow up with as a child – that there is goodness, honour, love – how do you reconcile this?

Were you also influenced by other American filmmakers?

Right now I'm excited by John Cassavetes films, because he maintains throughout his films the purity of love, of people's individuality, despite/within the complexity of serious human problems – stupidity, violence, desperation …

I grew up on Walt Disney and I believed it. We weren't allowed to watch television except for Walt Disney for 2 hours on Sunday nights. Walt Disney is like a fairy tale that's been cleansed. When I read the original Grimm's fairy tales they're quite dark. I didn't understand … evil – I couldn't accept it. I saw *The Texas Chainsaw Massacre*, and it totally upset me. After this film, I was trying to come to terms with the fact that in every relationship there is a combination of light and darkness. The video is called *"Within" Heaven and Hell* because they are interrelated. In the video there are 12 scenes, like the 12 stages of Christ and in each scene the ecstasy and despair are nearly inseparable.

You appropriate these images of heaven and hell from existing films. Is this the usual procedure you use in your videos?

I like to work in this way. And it is part of our times, like the way DJs are sampling music. I feel when you watch a movie you become the movie; when you listen to a fairy tale you become the fairy tale. These images have such resonance in your personal life. On the one hand, the media is all powerful, the entertainment industry, and is propaganda. On the other hand, I still believe people are able to internalise these images so deeply that they live them out in their independent imagination.

You get the feeling looking at your movie that it is one movie. In a way the images need each other.

It's curious to me that *Sound of Music* and *The Texas Chainsaw Massacre* have so many parallel sequences even though they're seemingly different types of film.

In spite of *The Sound of Music*'s apparent spirit of joy, it is to a large degree a story about a disfunctional family and their fucked up father. Captain Von Trapp is a dictatorial father whose children are alternatively oppressed or neglected by him. He is insincere to the woman he is first engaged to. And he allows the children to be rude and disrespectful to her. As children we hated her. She was like the ugly witch. Now I can see that she is extremely beautiful and it is poignant to witness her being forced to realise that the man who has pledged his life to her doesn't love her. Despite her pain, she is trying so hard to retain her dignity. As children we were in love with Captain Von Trapp and wanted to be in that type of family. We didn't understand the underlying issues in the movie.

The Texas Chainsaw Massacre talks about this family stress in an exaggerated way. The family is at a dinner table and they're just freaking out. And I have memories from my childhood, my mother brings the chicken, but my father doesn't like the chicken cooked that way, but nobody says anything. And my father is in a bad mood and my mother is trying to please him – all these kinds of tensions that exist in families.

Every fairy tale has this sexual background, in a Freudian way, a covered background of violence and sex, but never has it been used in as direct and open a way as you do it in your videos, in your work generally. By exposing these oppositions are you trying to highlight their differences or exemplify their unity?

The man who made the video with me, Mario Herrera, is from Texas. He saw *The Texas Chainsaw Massacre* on his first date at a drive-in; the girl he was with was so scared she dug her nails into his arm, and he still has these scratch marks 18 years later – his tattoo. That's one example where violence, passion and fear are closely related.

Western culture/religion instils the belief in the division between the body and soul, good and evil. Especially in film you see this schism. On one side there are romantic poetic films. Yet even radical films like Godard's *Breathless*, only infer sexuality. Now in Hollywood you see a little bit more, the back of a girl's butt having sex or something. And then you have pornography films: ding dong the bell rings and it's the post man, and then there's fucking, but there's no sensitivity, no drama and no emotion. For most people sex and inner emotions come together. I'm trying to form the truth. I'm curious also why it is never, well, why it is rarely seen.

You make drawings, you make photography, what's your relationship to these media and what are the things that keeps everything together?

I am the storyteller.

I was making drawings and people were often telling me I should be making films because the drawings were like a storyboard. Then I was curating video and some friends of mine who didn't speak much English misunderstood that I was making video, and wrongly remembered seeing my videos and liking them. I received many calls from people they knew in Europe to see my videos. I had never made a video before. Finally, I thought it's a sign for me to make videos.

Then out-of-the-blue this Chilean woman, Veronica Vega, returned to New York after an extended absence and called me. Although I hardly knew her, she said she had been thinking about me because she had just bought video editing equipment and thought I should make a video and she was going to help me make it tomorrow. This was the beginning of *Madame Bovary's Revenge (The Lovers)*.

The reason I tell you this story is because, the ways that things happen, through coincidences and friendships, and encounters that lead you on to your destiny, are really what the videos themselves are about. Like *The Lovers*, it's about a chance meeting of a man and a woman, they fall instantly in love and she leaves her entire life behind. Love forms her destiny.

Can we speak about *Madame Bovary's Revenge* because I think it is an interesting production. Why don't you start by explaining what Louis Malle's original film *The Lovers* is about.

It's a love story about a bourgeois married woman. Her husband doesn't pay much attention to her. She's Jeanne Moreau! She's like the most beautiful woman, and he doesn't pay much attention to her – a typical marriage and they have a child. She's leading a flash life, having a love affair with a famous jockey in Paris. Her husband invites her lover over to make a confrontation. She's racing back home to meet them, when her car breaks down and this young man, with obviously simple means, picks her up and drives her there. At the house she sort of sees through the young man's eyes and realises that she's unhappy, her husband is a bore, her lover is stupid and her life has become pointless. Taking a walk in the woods, she runs into the young man, they look at each other and they are completely in love and they start to make love over and over and over again. All night – they do it in the boat, they do it in the house, they do it everywhere. But every time the love scene starts, you know, they start to kiss and then it cuts short.

As movies do, especially in those times.

In the end what I really love about this movie (which is most likely the reason it was censored in the United States for many years) is in the morning she just walks out with the new guy and leaves everyone in the house astounded, her lover, her husband, everyone is like – where are you going – she just leaves with him. And then she says she has no regrets. Even though she has some doubts, she doesn't regret her decision.

No sin.

I really love this because you have for example *Madame Bovary*, all of these stories about women that curtail their freedom. They are punished, their families are punished, everyone dies. They're made into demonesses. And in this film Louis Malle allows her her freedom.

This is what mainly interested me in the film and also that it is a love story that is incredibly sexy and romantic. We framed our video with a girl masturbating watching the film *The Lovers*. It's a bit of a joke: women "get off" on romance – the stereotypical female "sexual" fantasy is falling in love.

On another level, the idea was to complete the love scenes. I used footage from *Behind the Green Doors* which is a classic seventies porno film with Marilyn Chambers. When she's making love with the man she's completely impassioned, it's like it's real love and they're really kissing. You never see this in a porn film. Marilyn Chambers looks a bit like Jeanne Moreau, so we were able to reedit the film using the footage. We had certain concerns, sexual concerns as women, like the scene where the man is licking the woman's pussy we wanted to be as long as the blow job scene – certain feminist concerns. Mainly, we thought it was important to show lovemaking as something natural. I found out after we made the video that during the filming of *The Lovers*, they were really making love. Then when Louis Malle edited the film, because of the way films are censored, he cut out all the explicit sex and expressed this through kissing and hand gestures. In actuality, we had completed his idea that wasn't possible in 1959 to do. As artists in the 1990s we have this freedom.

And you're not afraid to take away the freedom of imagination?

No, I like it. Personally, I like to see things as they are. I'm always curious. There are so many things you don't see – you don't know what it's like when other people are in bed, what it's like in their relationships, what goes on in their heads and what they talk about. All these things, you can only guess at, or see on TV, in movies, or read in novels. But is it real?

Veronica and I went on to make *Club Vanessa* for this reason. I always wanted to see intimacy as it is, but since I can't exactly spy on people, I explored privacy with myself and my friends/lovers. After working with *The Lovers*, we wanted to make a movie about the present, contemporary love … what really goes on in our lives.

In your book *Remember The Fourteen Days And Nights* you quote Clarice Lispector from *The Stream of Life:* "I refuse to become sad. Let's be happy. If you're not afraid of being happy, of just once trying this mad, profound happiness, you'll have the best of our truth." It has such an emphasis about happiness, but when you look at the movies or even the other work, you don't really get the feeling it's about happiness.

Right, that's true, actually. But they always have happy endings.

But some are ironical happy endings, honestly, for the viewer ….

I was working on a tragic story earlier this year and I ended up debating with myself whether or not I should let it have a sad ending. But I couldn't bear to do it. It goes against everything in myself. May be it's being American, I have to have a happy ending, or the way I was brought up. I must maintain hopefulness. The way I sustain myself is that I believe there is a positive way to approach life. It's not always so easy ….

But you know here in Europe this kind of goal, this vision of "happiness" is considered to be very American, like an American cliché. It's in your constitution. I don't know any other constitution where happiness is part of the state goals. And also like in California you feel obligated to be happy. If you are not happy, you should be punished, something must be wrong. You have to see a psychiatrist, as a result of not being happy. And you tell me now it's also about happiness. But again looking at the video and the other work, I feel like it is a different form of happiness.

Clarice Lispector is a Brazilian writer. Her statement was meant to be a rebellion against God, against being a receptacle for pain. For me, that quote is very specific because it is related to a particular set of drawings which were made at a point where two people were in absolute despair with their relationships and didn't know how to go on living. They decided to try and create a realm of light and happiness together – a calculated experiment – in order to radiate this energy back into their personal relationships. They hoped to transform them in this way. With these drawings I thought if you could create good memories over and over you could forge that path. So I drew a cyclical Kama Sutra of love, like a mantra, in order to propagate a loving outlook. I don't know, I can't say from any personal evidence that this experiment worked. Sometimes deep emotions are too real to simply resolve with magic and hope. In any case, it was the premise for these drawings.

Can you speak a little bit about your wall drawings and your use of various media simultaneously?

I'm trying to create an atmosphere that's vital. That people can enter into and feel. Personally, I became bored making a single object to hang on a wall. So I began first to draw on the walls, to make this environment in my house which was like an erotic harem, like a dance club. All the things which excited me and made me feel alive weren't at the time in art galleries.

In the exhibition I saw at XL in New York, I got the feeling the gallery became like a personal living room.

I was trying to orchestrate it like a piece of classical music. First there were the little drawings which were like scales. Then came the wall drawing which was massive yet "pianissimo" at the same time. Finally the video was like the crescendo. Looking at Bambi on the wall you could hear the video sounds, like the song *Edelwyss* or the screaming from *The Texas Chainsaw Massacre*. Everything started to become interconnected.

And very personal. You got the feeling that someone lived there for some time and started to draw on the wall and finished it after a very long stay in this apartment.

Yes, it's my aura.

Do you believe in heroic fairy tale love?

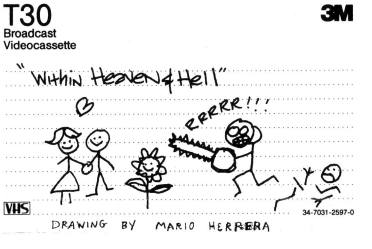

You meet a "prince", fall in love; this part of the fairy tale is reality. Many people experience this. But actually most love is anti-heroic – you end up hurting each other. My question is how do people live "happily ever after" ... there are so many deep problems and complexities inherent in relationships. Most people are not prepared to deal with their difficulties. Still, I believe that love is one of the highest ways to experience self-knowledge, spirituality and ... pleasure.

There is a lot of sex in your work.

Well sex plays a part. *Club Vanessa*, a video about the present, begins with me fantasising about what our lives will be like in the future. That we would have a lot of lovers, that there would be real love but no jealousy.

We were trying to reinvest ourselves in this 60s utopian vision and explore in which ways these ideals have affected us. Also, we were reinvesting ourselves in the feminist history of body performance, reanalysing the female experience as an object of sexual desire.

So the utopian vision ended up in *Club Vanessa*.

That's reality.

Matthew Yokobosky is the associate curator, film and video, Whitney Museum of American Art, New York, has curated the recent exhibitions *Fashion & Film, No Wave Cinema, 78–87,* and *Charles Atlas: The Hanged One.* He is also known as the designer of numerous theater productions and large-scale art exhibitions.

Gerald Matt is director of the Kunsthalle Wien, Vienna; part-time lecturer at the Hochschule für angewandte Kunst Wien, Vienna; member of board of the Vorarlberger Kunstvereins/Magazin 4, Bregenz, Austria.

Special thanks for assistance on this project:

Andrew Byrom

Nigel Coates

Deborah Drier

Delfina StudioTrust, London

Lucas Gehrmann

Mark Gregson, MJT Productions, London

Mario Herrera

Simon Josebury

Walter Keller

Xavier Laboulbenne, Gallery XL, New York

Bettina Leidl

Gerald Matt

Uscha Pohl

Jason Rand

Christine Rossini

Mike Sale

Bernhard Winkler

Matthew Yokobosky

I dreamed of the dessert
a beautiful desert
 with all the possibilities
of more & more beauty
& that it was beautiful
but beyond & deeper
it would be even more
beautiful still and the anticipation
of the deepest beauty was
exciting me greatly!